IMAGES
of America

ANN ARBOR

IN THE 20TH CENTURY

A PHOTOGRAPHIC HISTORY

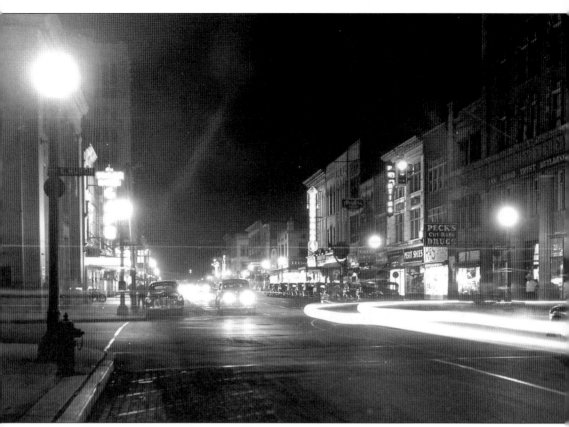

Main Street at Night, Looking South from Huron Street.

IMAGES
of America

ANN ARBOR
IN THE 20TH CENTURY
A PHOTOGRAPHIC HISTORY

Grace Shackman

ARCADIA

First Printed 2002.
Reprinted 2003.

Published by Arcadia Publishing,
an imprint of Tempus Publishing, Inc.
3047 N. Lincoln Ave., Suite 410
Chicago, IL 60657

Printed in Great Britain.

Library of Congress Catalog Card Number: 2002107396

For all general information contact Arcadia Publishing at:
Telephone 843-853-2070
Fax 843-853-0044
E-Mail sales@arcadiapublishing.com

For customer service and orders:
Toll-Free 1-888-313-2665

Visit us on the internet at http://www.arcadiapublishing.com

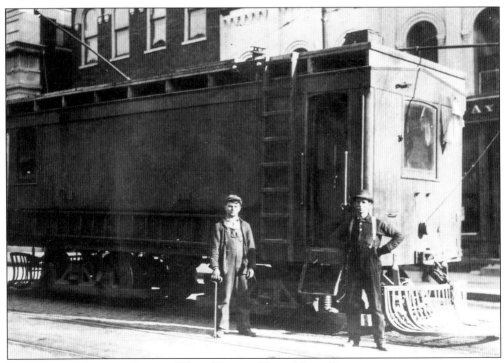

INTERURBAN FREIGHT CAR ON WEST HURON NEAR MAIN STREET.

CONTENTS

ACKNOWLEDGMENTS

Everyone I talked to was so encouraging about my project and so willing to give me the information I requested or loan me pictures, I hardly know where to start with the acknowledgments.

The staff at the University of Michigan Bentley Historical Library was helpful as always, especially Karen Jania who gave me useful picture advice and Malgosia Myc and Stephanie Alvarez who cheerfully brought out box after box of photographs for me to look through. We are very lucky in this community to have such a rich repository of local history information as found at the Bentley. Special thanks should go to Sam Sturgis, who collected an enormous number of photographs and deposited them at the Bentley for future researchers' use.

People at the *Ann Arbor Observer*, a publication that I have been involved with for more than 20 years, were also a great help, especially John Hilton and Penny Schreiber, who let me rifle through their picture files and also copied a few on disc for me. Penny Schreiber, assisted by Paul Schwankl, did a careful edit of the text. My good friends Janis Bobrin and Brett Ashley also looked at my manuscript and made helpful suggestions. Pete Lindberg advised us on how to copy pictures and also loaned us the equipment.

The following people loaned me original pictures: Doug Smith, Walter Metzger, Ruth Dalitz, Doug Price, Irene Hieber, Bob Kuhn, Mike Logghe, Nancy Crosby, Olive Conant, Richard Wood, Linda Strodtman, Ann Staiger, Penny Schreiber, Herb Pfabe Jr., Balthazar Korab, Richard Wood, Diane Good, Fay Muehlig, Susan Caya, Pauline Walters, Susan Wineberg. Others loaned me copies of Bentley photographs, saving the work of reproducing them: Julie Truettner, Barry LaRue, Bob Grese, Ellen Offen, Ray Detter, Louisa Pieper, and Don Hammond. My son-in-law Chris Jackson and friend John Johnson helped me date pictures by identifying cars.

So many people helped with information that I don't dare start listing them for fear of leaving someone out. But I have to mention the callers on the Ted Heusel Show, who not only provided specific information but also gave me a sense of what Ann Arbor was like before World War II.

And last, even though he doesn't want me to, I have to mention my husband, Stan Shackman, who spent many hours at the Bentley copying pictures, and then as many at home scanning them. He worked so hard on this book, he hardly felt like he had just retired.

INTRODUCTION

Ann Arbor began the 20th century as a small manufacturing and regional retail center not very different from other towns of its size except for the presence of the University of Michigan. By the end of the century, it had changed into a cosmopolitan town with people from all over the world. The population in 1900 was about 14,500; by 2000 it was 114,024, including about 38,000 students.

When writing my book on Ann Arbor in the 19th century, I faced the challenge of using a limited number of photographs to illustrate Ann Arbor's history. Working on this book, I had the problem of how to choose the best images from hundreds of possibilities. The choices end up being personal; I took a leap of faith that what is interesting to me will be interesting to others. I know I have indulged my fondness for circus animals, movie theaters, and interurbans, but those are the rewards of authorship.

Given a choice between an old photograph that shows the town in a different light, and a more recent one of a scene that looks the same today, I have opted for the older one, but I've tried to bring the subject up-to-date in the text. I've organized the book by topic, starting with downtown, because I believe that is most people's immediate visual picture of Ann Arbor. I then moved on to transportation because the introduction of the car has immensely changed 20th-century life. As I developed the rest of the topics, I was often aware that pictures could fit under several headings, but the multi-dimensional aspects of history are what I believe makes it fascinating. The University of Michigan appears throughout the book, and I have tried to show how its presence impacted the town, both in the chapter devoted directly to it and where it is relevant in other chapters. Architects and architectural styles are mentioned throughout whenever pertinent.

If I know the date of a photo I have included it. But in many cases, the photos have been handed down by descendants who have no idea of the actual date the pictures were taken. In those situations, I tried to include enough information in the captions to give an idea of the time periods.

Ann Arbor is a wonderful town, with fascinating people and an abundance of activities. During my years of researching local history, I've found the community very supportive of what I'm doing, and countless people have encouraged me on the way. I hope some of this comes out in the book.

Grace Shackman

One
DOWNTOWN

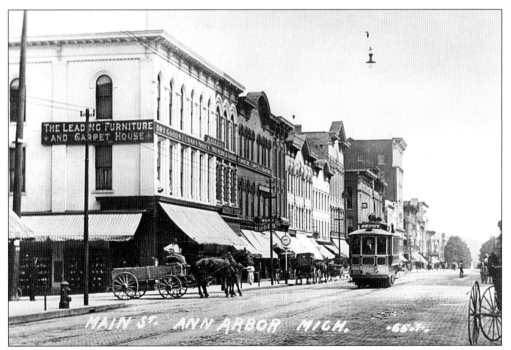

MAIN STREET LOOKING NORTH FROM LIBERTY STREET, C. 1908. By the beginning of the 20th century, Ann Arbor's Main Street was clearly the region's center of trade, with rows of brick buildings, brick paving (installed in 1898), and even a skyscraper, the seven-story Glazier Building (just beyond the trolley). Mack and Company, Ann Arbor's biggest department store, is in the foreground. People traveled by trolley, as seen here coming from the depot, and also by foot, and horse and buggy.

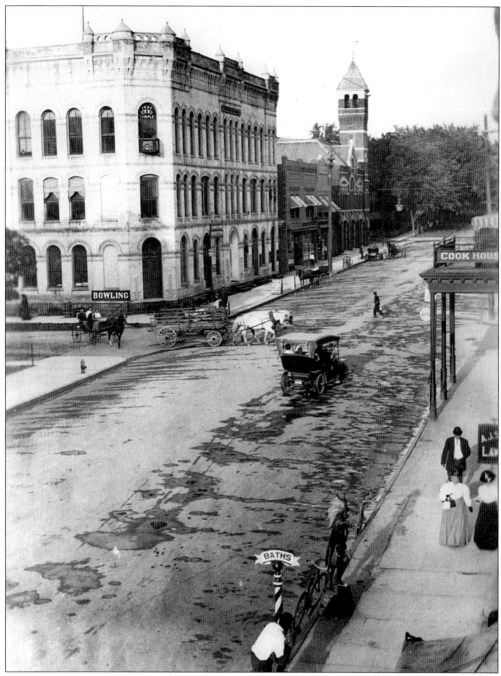

HURON STREET LOOKING EAST TO FOURTH AND FIFTH AVENUES, C. 1909. Although the retail district was expanding south along Main Street, the streets around the courthouse were still the center of town. Cook House, (right) directly across from the southeast corner of the courthouse lawn, was the site of a hotel since 1836. Closer to the foreground are law offices—ideally located across from the courthouse—and a public bath establishment. Although Ann Arbor had running water beginning in 1885, not everyone had indoor plumbing. The 1882 fire station is in background.

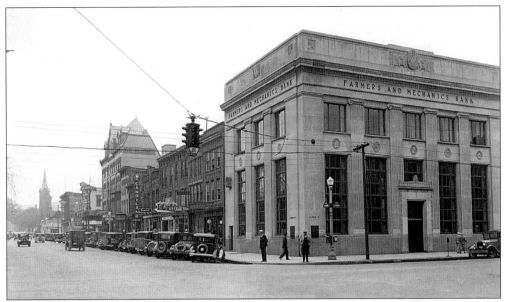

HURON STREET LOOKING EAST FROM MAIN STREET, AFTER 1927. The new Farmers and Mechanics Bank, rebuilt after an interurban car crashed into it in 1927 (see page 30), was adjacent to a row of stores offering quick lunches, sweets, cigars, and telegraph services to those who frequented the courthouse across the street. The building with the pointed french roof is the Allenel, the new name for Cook House, rebuilt after a 1910 fire. The spire in the background belongs to the Presbyterian Church, now the site of the *Ann Arbor News*.

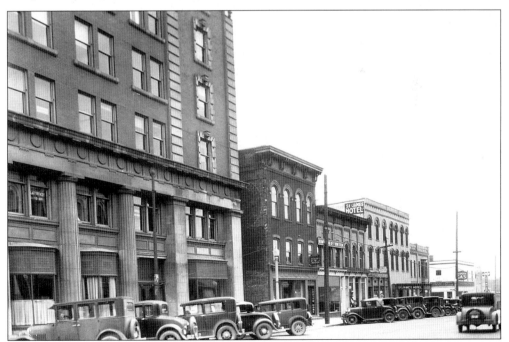

HURON STREET LOOKING WEST FROM MAIN STREET, JUNE 24, 1932. People standing at the location depicted in the previous picture would see this view if they turned completely around. In the 1930s, this stretch of Huron Street was still a pedestrian-friendly shopping area.

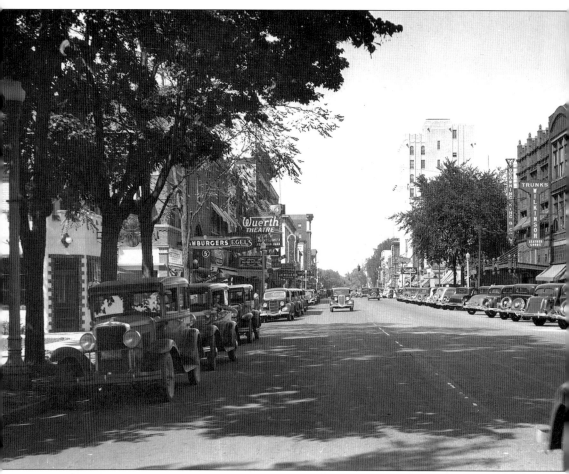

MAIN STREET, LOOKING NORTH FROM WILLIAM STREET, 1936. Main Street development continued moving south in the 1930s. In 1929, the ten-story First National Building (right), took the Glazier Building's place as the town's tallest building. The Wuerth Theater can be seen on the left side of the street. People were now coming downtown not only to shop but also to take in a movie.

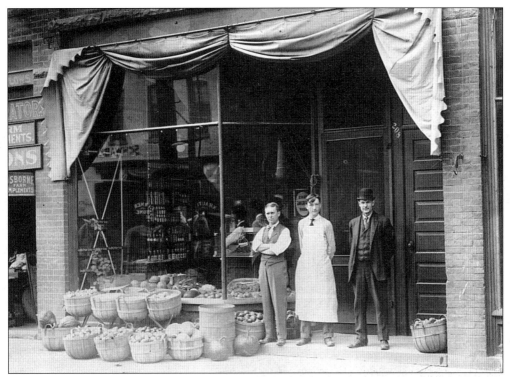

PROCHNOW'S GROCERY STORE, 208 SOUTH ASHLEY STREET, C. 1910. At the beginning of the century, the necessities of life were the main business of downtown. David Prochnow, a member of Ann Arbor's German community, who made up a large percentage of the town's retailers and craftsmen, sold every kind of food except meat. Signs for plows and farm implements can be seen on the left at the edge of the Hertler Building.

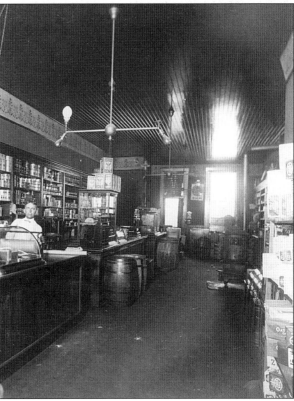

INTERIOR OF PROCHNOW'S. To supplement the products sold in bushels, barrels, and cases, Prochnow offered prepackaged items such as crackers. The store was illuminated by a combination of gas and electric power.

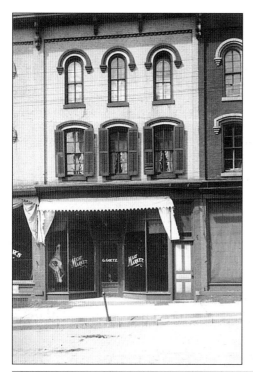

GOETZ MEAT MARKET, 118 WEST LIBERTY STREET. Note the curtains in the second-floor window. George and Mathilda Goetz ran their meat market from 1905 to 1913 on the first floor and lived upstairs with their three children. The Goetzes worked long hours, staying open until midnight on Saturdays, when the farmers came to town. George Goetz made his own lard, sausage, bologna, knockwurst, and frankfurters. Mathilda cooked and served family meals on the first floor so that she could be available to help customers. Children who came with their parents were given free pieces of bologna, and customers' dogs often stopped by on their own for free bones.

KROGERS, 224 SOUTH STATE STREET, CORNER OF LIBERTY STREET, 1928. In the 1920s, locally owned grocery and meat markets were threatened by national chains that could offer lower prices by buying in bulk. By 1928, there were six Krogers in Ann Arbor and three Great Atlantic and Pacific Tea stores.

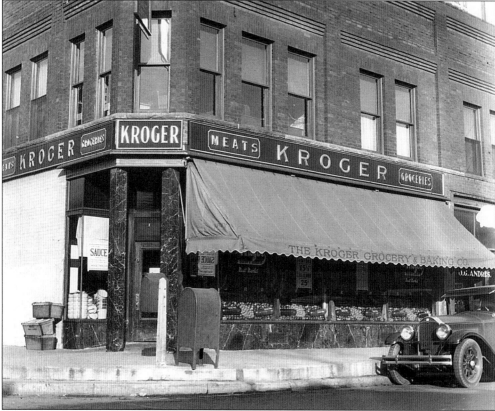

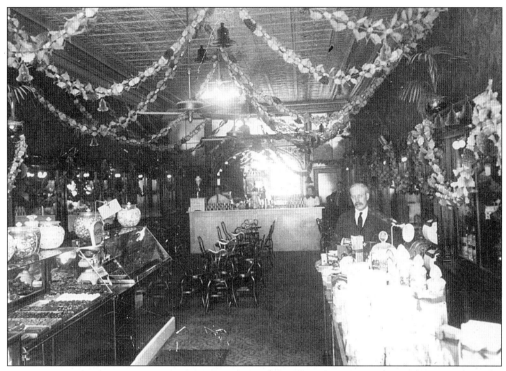

TRUBEY'S ICE CREAM PARLOR, 116 SOUTH MAIN STREET. In the days before refrigerators, most people went out for ice cream. Justin Trubey made ice cream and candy on the premises and also served light lunches at the ice cream parlor he opened in 1909.

SUGAR BOWL, 109 SOUTH MAIN STREET. Trubey's main competition was the Sugar Bowl across the street, the first important commercial business in town owned by Greeks. Greeks began immigrating to Ann Arbor in the early 20th century. After the Preketes brothers opened the Sugar Bowl in 1910, other Greeks started businesses in the courthouse area.

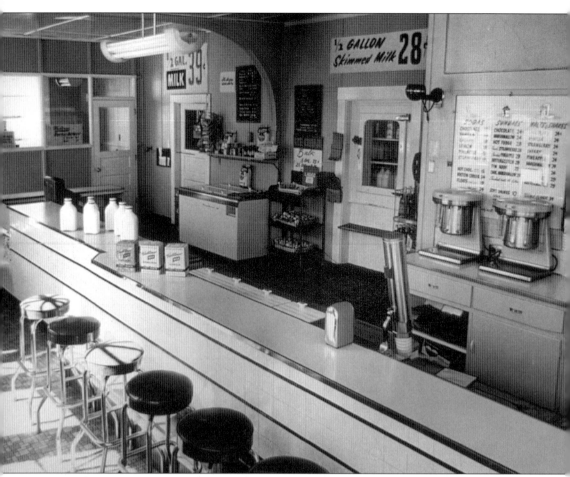

WASHTENAW DAIRY, 602 SOUTH ASHLEY STREET, 1950S. By the end of the century, Trubey's and the Sugar Bowl were long gone, but the Washtenaw Dairy, which began operating in 1936, is still going strong. Hugely popular with people of all ages, the dairy is known for its homemade doughnuts and giant ice cream cones.

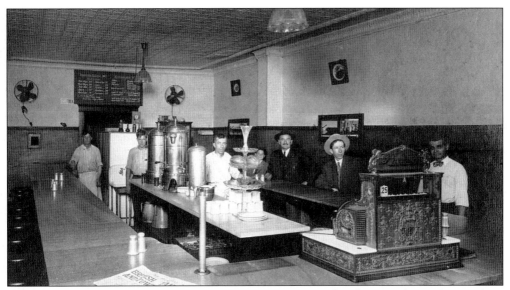

PROCHNOW'S DAIRY LUNCH, 104 EAST HURON STREET. Theodore Prochnow (owner from 1902–29 and again from 1937–40) is standing behind the counter on the right. He served mainly a male clientele, often men who came to town to do business at the courthouse across the street. "Grub for the workingmen" is how his nephew Derwood Prochnow described the fare. "Nothing fancy—mainly breakfast, and lunch, meat, potatoes, gravy, vegetables—he didn't monkey with salad," explained Derwood. Dessert consisted of homemade pies and excellent coffee. Prochnow often cooked with a cigar hanging out of his mouth. On one occasion, customer Morrie Dalitz found a cigar butt in his oatmeal. Quite a few years went by before Dalitz was able to eat oatmeal again.

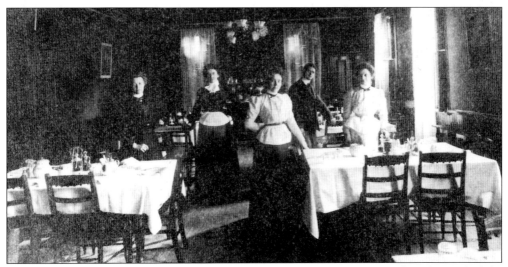

AMERICAN HOTEL DINING ROOM, 123 WEST WASHINGTON STREET. At the other end of the spectrum, the American Hotel Dining Room offered fancy meals on white linen tablecloths served by waitresses in starched uniforms and prepared by cooks who probably didn't smoke cigars. Open to townsfolk as well as hotel guests, the restaurant was especially popular for Sunday dinner. In 1927, the dining room became the Pontiac showroom for Staebler & Son's car dealership. It is now the back part of Sweetwaters Cafe.

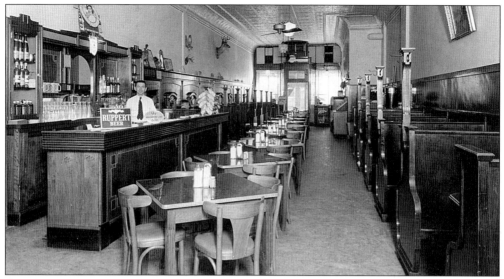

OLD GERMAN RESTAURANT, 120 WEST WASHINGTON STREET. Gottlob Schumacher, owner of the Old German from 1936 to 1946, poses behind the counter. In the 1920s, German restaurants began supplementing lunch counters. In 1946, Fritz Metzger moved from Huron Street, where he had been operating a restaurant, to take over the Old German. Fritz eventually passed the place on to his son, Bud, who ran it until 1995. At the century's end it had become the Grizzly Peak Brewing Company, signaling a new trend in Ann Arbor restaurants.

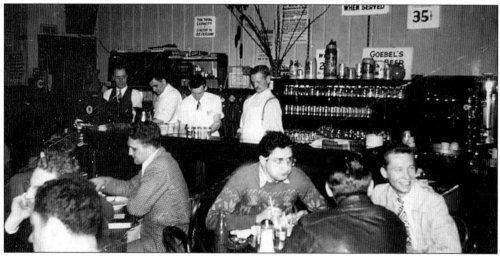

METZGER'S RESTAURANT, 203 EAST WASHINGTON STREET, 1948. Metzger's Restaurant was a popular spot for U of M students who poured into town taking advantage of the G.I. bill, which funded higher education for World War II veterans. Note how formally dressed they are by today's standards. Bill Metzger, brother of Fritz Metzger who owned the Old German, founded Metzger's in 1928. A third brother, Gottfried Metzger, baked bread for both establishments. Pictured behind the counter from left to right are Martin Rempf, president of the Schwaben Verein; Bill's two sons, Hans and Walter; and Julius Schipple, who did everything from bartending to janitorial work. Since the time of this photo, the restaurant has been managed by two subsequent generations of the Metzger family, first Walter, and now by two of his children, John and Heidi, who run it at a new location in Scio township.

18

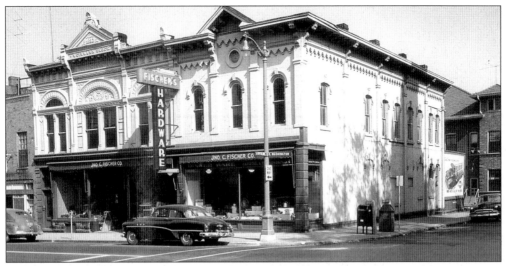

FISCHER HARDWARE, 219–223 EAST WASHINGTON STREET. Downtown was full of hardware stores, and each one had a specialty, like sewing machines, furnaces, or building materials. Fischer's, at this location from 1937 to 1982, was the first hardware store in town to specialize in housewares. It also supplied U of M researchers with lab apparatus. Schlenker's on West William Street was the last hardware store downtown. It closed in 1995. Note old city hall at back right.

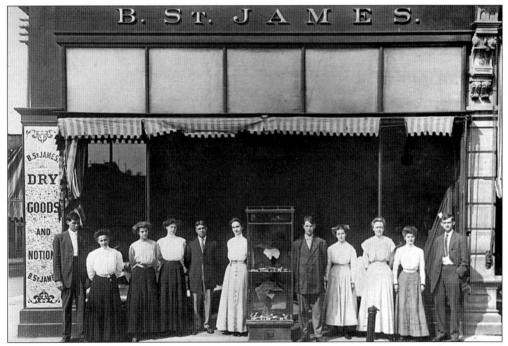

ST. JAMES DRY GOODS & NOTIONS, 126 SOUTH MAIN STREET, 1909. A dry goods store stood on this corner for 115 years. Philip Bach opened Bach & Abel in 1865. In 1911, Bertha Muehlig (third from right), bookkeeper for Bruno St. James, bought the business and renamed it Muehlig's. She ran it until she died in 1955. Muehlig sold everything imaginable, continuing to carry long underwear and handkerchiefs well after they were out of fashion. Former customers remember seeing her sitting on the mezzanine working on her accounts, a visor shading her eyes.

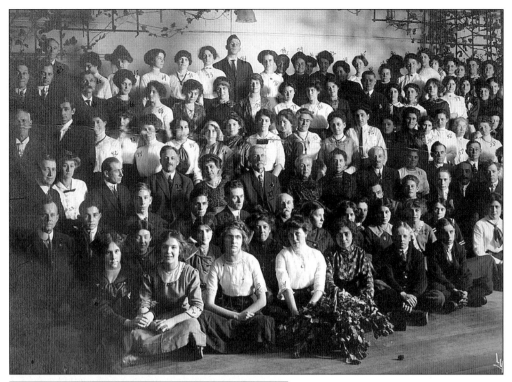

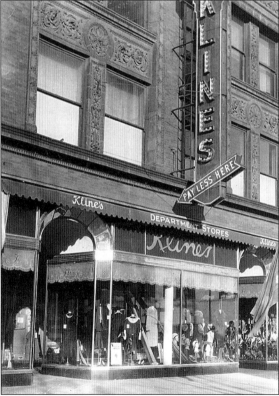

STAFF OF MACK DEPARTMENT STORE, 216–224 SOUTH MAIN STREET, 1912. From 1860 to 1939, Mack's was *the* place to shop. The store featured a wide variety of merchandise and a knowledgeable staff, including Myrtle Dusty, who taught generations of customers how to knit, and Mary Rogers, who played the latest sheet music on the piano. Mack's was a training ground for the next generation of retailers. Walter Mast of Mast's Shoes worked in the shoe department, Mae Van Buren of the Van Buren Shop worked in undergarments, and Guernsey Collins of the Collins Shop worked in women's ready-to-wear.

KLINE'S DEPARTMENT STORE, 306–312 SOUTH MAIN STREET. Partially filling the void left by Mack's, Kline's sold moderately priced clothing and household goods from 1930 to 1994.

SCHAEBERLE MUSIC HOUSE, 110 SOUTH MAIN STREET, 1920s. People also came downtown for luxuries, such as music supplies. In 1928, Ernst Schaeberle's offerings included Orthophonic Victrolas and Records and Radiola radio sets and supplies. Note the beautiful terracotta detailing on the front of the building, popular when the building was built in 1908 and still in place today.

S.S. KRESGE COMPANY, 200 SOUTH MAIN STREET, 1928. In the 1920s, chain stores competed with local merchants and with each other. A Woolworth's was located on Main Street, a block north of Kresge's.

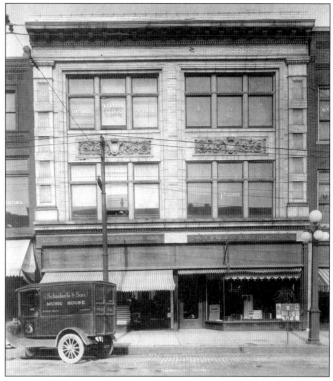

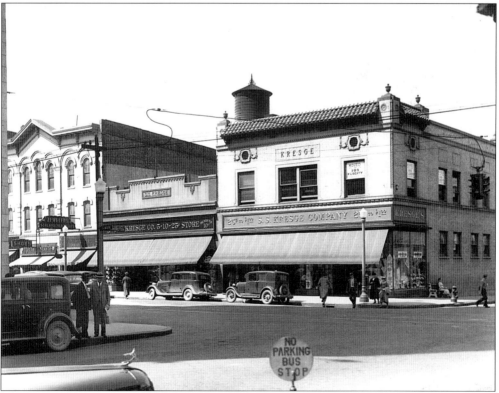

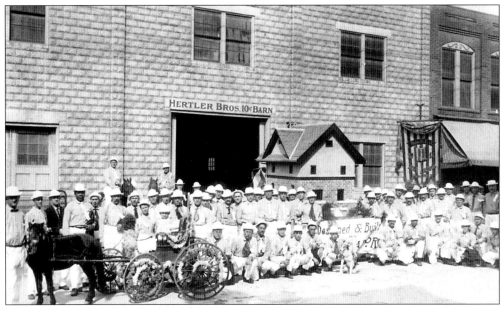

HERTLER'S, 210 SOUTH ASHLEY STREET, FARMERS' DAY, 1916. Stores west of Main Street catered primarily to farmers. Ehnis & Sons on West Liberty Street sold work clothes, and Ann Arbor Implement on First Street sold farm equipment. Farmers who came to town on Saturday night after chores could pay 10¢ to leave their horses at Hertler's, a store started in 1906 by brothers George, Gottlob, and Herman Hertler. Their sister Emma did the bookkeeping. Today the store is Downtown Home & Garden. The horse stalls are still in the basement.

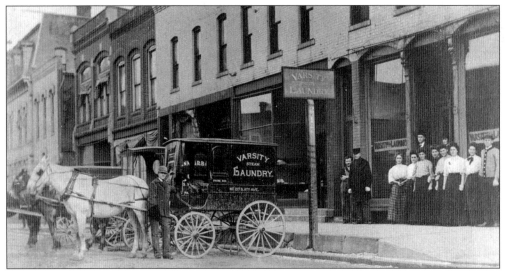

VARSITY LAUNDRY, 215–217 SOUTH FOURTH AVENUE, 1903. Service businesses like laundries were also located downtown. In 1903, steaming laundry was a new idea, replacing hand washing. Varsity's original owners, Fred Lantz and H.B. Tenny (in derby) stand in the doorway; the third owner, Clarence Snyder, is at the far right. The man in the long black coat at the left is the coal man who fed the steam boiler. The women did the pressing, sewing, ironing, and hand touch-up work. The building at left was a funeral parlor. Notice the hearse just behind the laundry wagons.

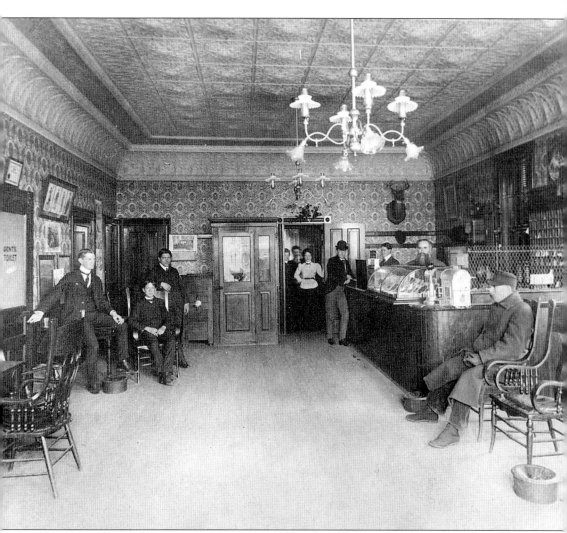

AMERICAN HOTEL LOBBY, 123 WEST WASHINGTON STREET, C. 1905. Owner Michael Staebler stands behind the desk with the rest of his staff posed around the room. At right is the horse-and-wagon driver who met incoming trains. The door at the back led to the dining room pictured earlier (see page 17). Before car travel made day trips easier, hotel guests often included salesmen who would come for the week and set up sample rooms, and gangs of repairmen from the Bell Telephone Company or Detroit Edison. May Festival musicians who appeared at Hill Auditorium and theater troupes who performed at the Majestic Theater also returned year after year. The space is now the front of Sweetwaters Cafe.

SOUTH MAIN STREET AT THE NORTHWEST CORNER OF WEST WASHINGTON STREET, 1940s. Although looking a bit shabbier as the century reached its mid-point, downtown remained a viable shopping area.

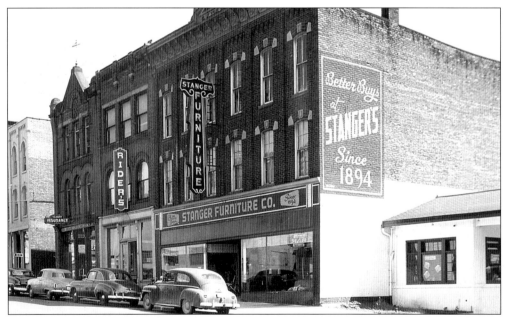

LIBERTY STREET BETWEEN MAIN STREET AND ASHLEY STREET, 1950s. In the post-World War II years, downtown Ann Arbor began to look run-down. Fortunately, most of the prime 19th-century buildings were not removed to make room for parking, as happened in many other towns of the same vintage. In 1976, the nation's Bicentennial celebration rekindled an appreciation of old buildings and many of Ann Arbor's were restored, including the Philip Bach Building above (and page 19) and the Haarer Building, now West Side Book Store.

Two
TRANSPORTATION

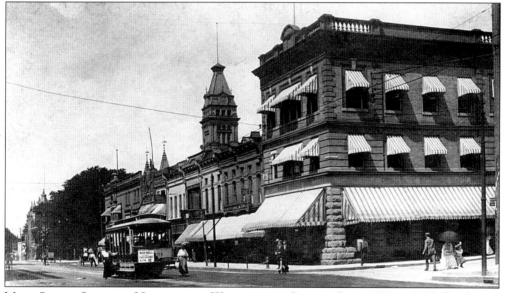

MAIN STREET LOOKING NORTH FROM WASHINGTON STREET. From 1890 to 1925, the electric streetcar provided public transportation. The trolley in the picture has had its windows removed to let the summer air in, and it advertises a baseball game at 8 p.m. at the City fairgrounds (then at Burns Park), admission 10¢. Although the photo was obviously taken in the summer, the people on the street don't appear to be dressed for warm weather, at least by present standards. The courthouse tower looms in the background.

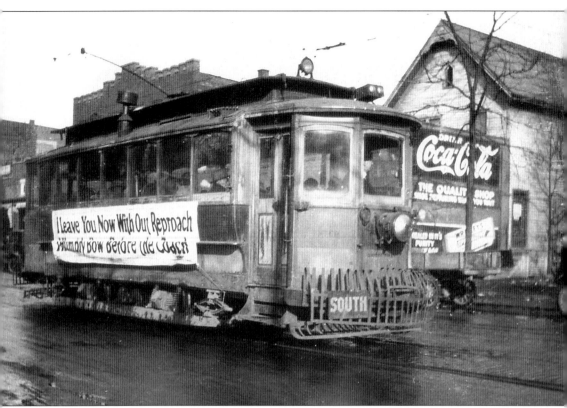

OLD TROLLEY. Trolley use was on the wane by the 1920s. Although conductors were replaced with collection boxes to reduce labor costs, the trolley business was still not lucrative enough to justify purchasing new cars.

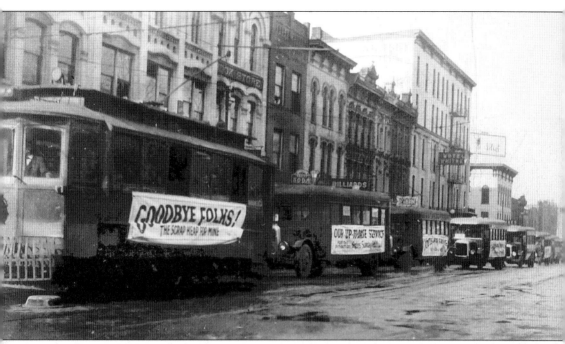

BUSES REPLACING TROLLEYS, JANUARY 30, 1925. "Goodbye folks, it's the scrap heap for me," read the banner on the lone streetcar. Twelve new buses followed behind, with a band playing funeral dirges in the first bus.

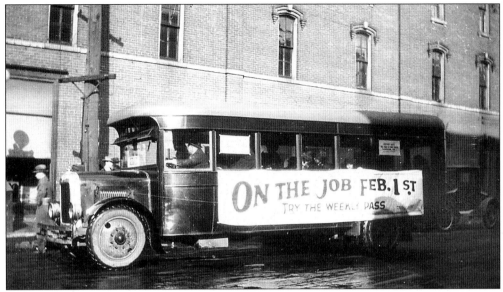

NEW BUS, 1925. The new buses were trying hard to drum up business.

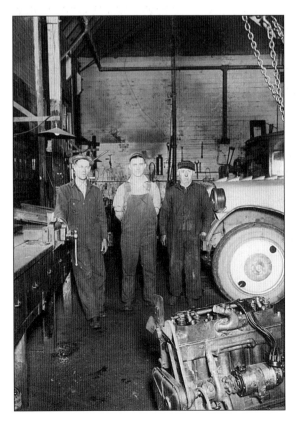

BUS REPAIR GARAGE. Luther Eagle, Arthur Rohde, and Clinton Barrow repaired buses in a garage on Ann Street west of Ashley Street.

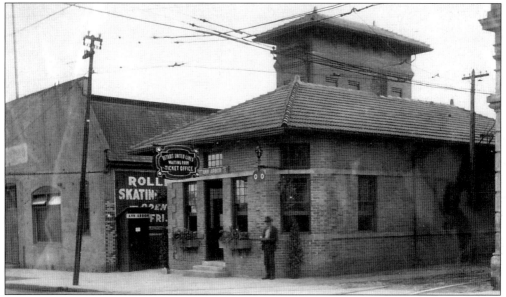

INTERURBAN STATION, 116 WEST HURON STREET. Built about 1898, the tower held the transformers leading to the DC rotary converter. The Wyman Roller Rink next door, built in 1884, was the first rink in town, predating the big roller skating craze that hit Ann Arbor in the 1920s.

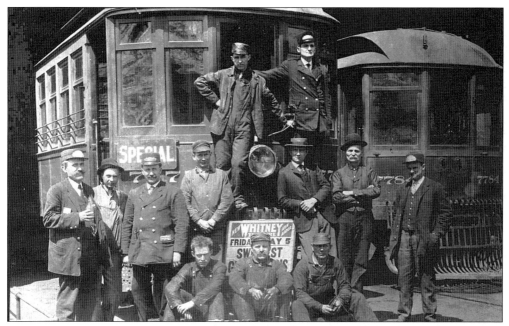

INTERURBAN CREW, C. 1908. Interurbans, electrically powered like trolleys, but larger, ran between local towns from 1891 to 1929. This crew, posed at the Ypsilanti interurban barn in front of a train marked "Special" and an ad for the Whitney Theater, is probably getting ready for an excursion to see a performance in Ann Arbor. Interurbans were sometimes hired for special occasions, for example, to take people to dances at the Washtenaw Country Club on Packard Road.

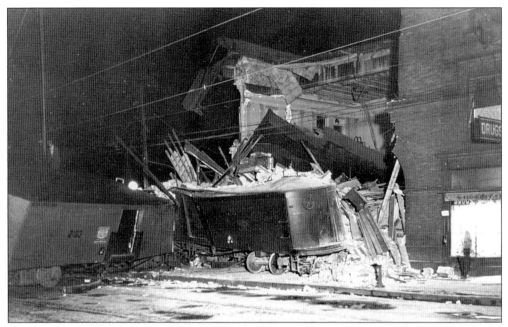

INTERURBAN CRASH, SOUTHEAST CORNER OF HURON STREET AND MAIN STREET, AS SEEN FROM MAIN STREET, 1927. On the night of August 5, 1927, two interurban freight cars broke loose from their moorings, near what is now Veterans Park, and came rolling down Jackson Avenue, gaining momentum along the way. When the cars reached Main Street, they were going too fast to take the turn and crashed into the Farmers and Mechanics Bank's lobby, completely destroying the building. Although late-night customers at two restaurants on either side of the bank—Prochnow's and the Sugar Bowl—felt the impact, no one was hurt.

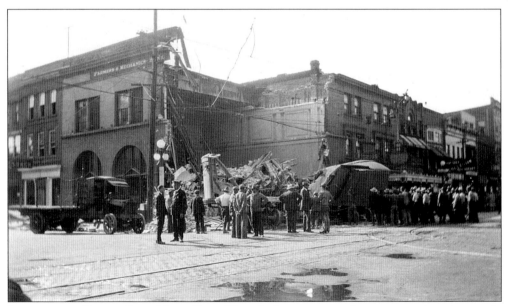

INTERURBAN CRASH SITE, NEXT DAY. The whole town turned out to examine the wreck. While the building was being rebuilt, the bank set up temporary headquarters at the Cornwell Building, a block away at the corner of Huron Street and Fourth Street.

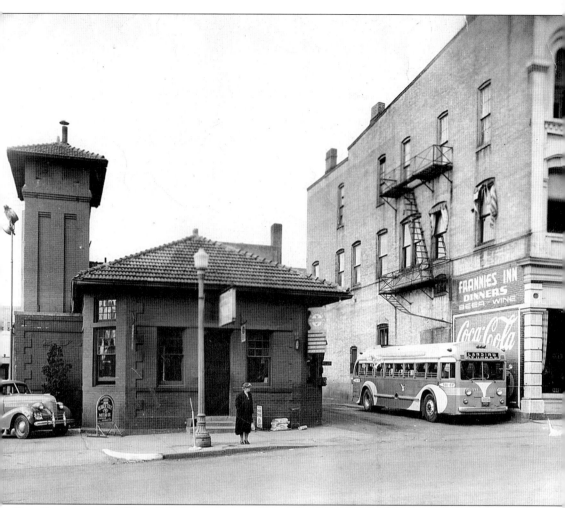

BUS STATION, 116 WEST HURON STREET. After the interurban went out of service in 1929, buses replaced them, as they had replaced the trolleys. The old interurban station became a bus station. The unneeded tower remained as a reminder of the station's former use.

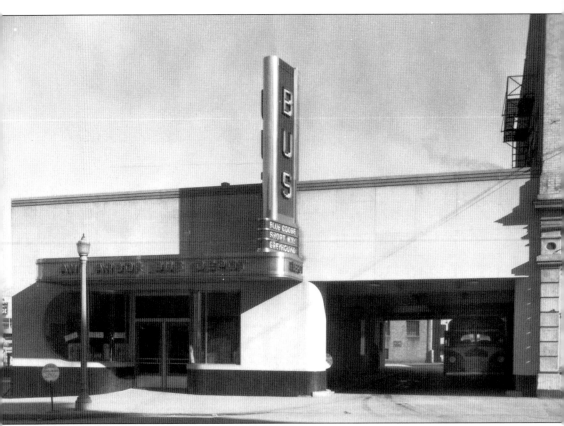

New Bus Station, 116 West Huron Street, 1940. The new bus station, still one of the town's art deco treasures, was designed by the architecture firm of Banfield and Cumming of Cleveland in association with Ann Arbor architect Douglas Loree.

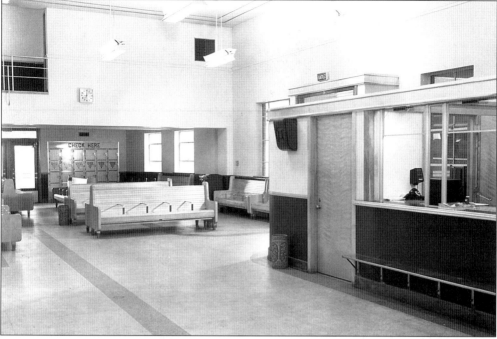

INSIDE THE NEW BUS STATION, 1940. Complete with newsstand and restaurant, the station's interior illustrates how popular and important bus travel was in the 1940s.

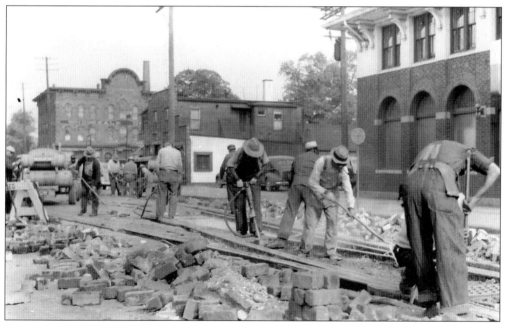

REMOVING INTERURBAN TRACKS ON EAST CATHERINE STREET, 1941. The interurban tracks remained in place for many years, probably because money for municipal projects was scarce during the Depression. In 1939, WPA crews began tearing out the track on Main Street, reaching Catherine Street a few years later. The Ann Arbor Dairy, now a city parking lot at Fourth Avenue and Catherine Street, is on the right.

Horse and Wagon and Car Waiting for the Train to Arrive, Michigan Central Train Station, 401 Depot Street, c. 1913. In the years before World War II, people preferred taking trains for long trips. This magnificent fieldstone station, built in 1886, served as a grand entrance to the city. Disembarking passengers ranged from students returning to school to celebrities arriving to perform at Hill Auditorium. A partial list of notables who came to Ann Arbor via train included Victor Borge, Meredith Willson, Gene Krupa, Benny Goodman, Pablo Casals, and Ignancy Paderewski, who arrived with his own sleeping car.

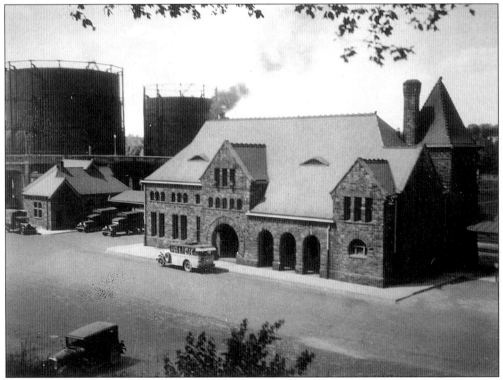

Train Station with a Bus in Front. Trolleys stopped going down the steep hill to the station when a brake failure in 1902 caused one to run into the station. When buses took over in 1925, they were able to take passengers all the way to the entrance, a boon for people with heavy luggage. Note the gas storage tanks in the background. After an 1895 explosion, the gas plant moved to the north side of the tracks, its location in this photo.

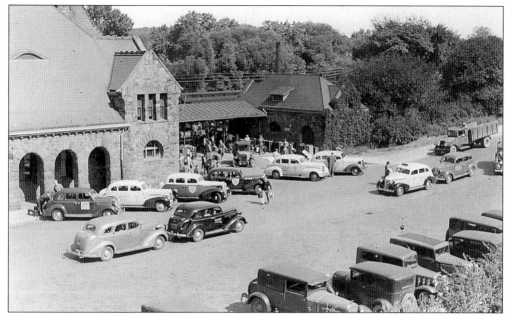

CARS IN FRONT OF TRAIN STATION, 1937. By the late 1930s, car ownership had increased, but gas and tire rationing during World War II led to train travel's last hurrah. After the war, surge of car ownership and interstate highway construction resulted in a decrease in passenger train travel. In 1969, the station was transformed into the Gandy Dancer restaurant.

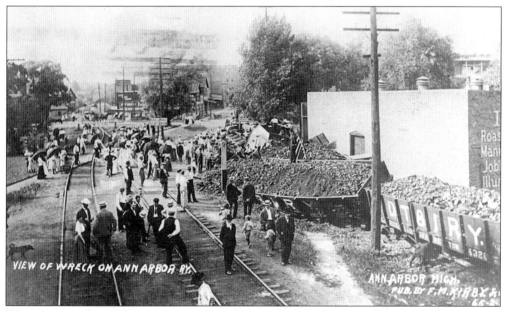

WRECK OF A COAL CAR ON THE ANN ARBOR RAILROAD, ONE BLOCK NORTH OF THE ASHLEY STREET DEPOT, 1908. The Ann Arbor Railroad, running from Toledo to Frankfort, was not as glamorous as the Michigan Central Railroad. But the smaller railroad served a practical purpose, bringing much-needed supplies to town, including ice, lumber, farm equipment, and coal. When a wreck occurred on either railroad line, the whole town came out to see it. People often brought along lunch and spent the day.

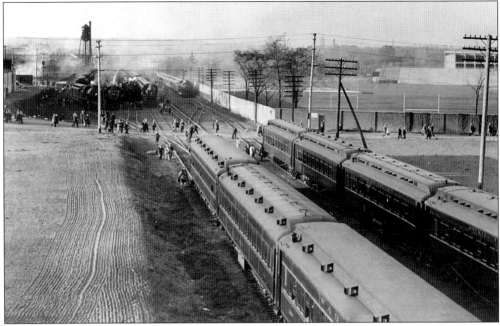

TRAINS ARRIVING FOR A UNIVERSITY FOOTBALL GAME. During football season, trains arrived carrying football fans from all over the Midwest. Train buffs were in heaven examining the enormous variety of train stock commandeered for these trips.

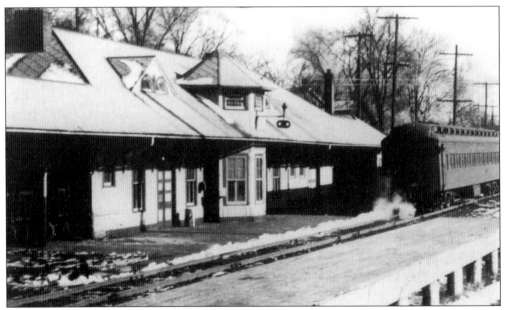

PASSENGER TRAIN LEAVING THE ANN ARBOR RAILROAD DEPOT, 416 SOUTH ASHLEY STREET, 1949. Passengers took the Annie, as the Ann Arbor Railroad was affectionately called, to Whitmore Lake for a day of swimming or a night of dancing, or even to the end of the line to Frankfort on Lake Michigan for a longer vacation. Passenger service received a reprieve during World War II, when the railroad was used to transport troops, but ended altogether in 1950. Today the station is a Montessori nursery school.

Three
CARS CHANGE
THE WAY OF LIFE

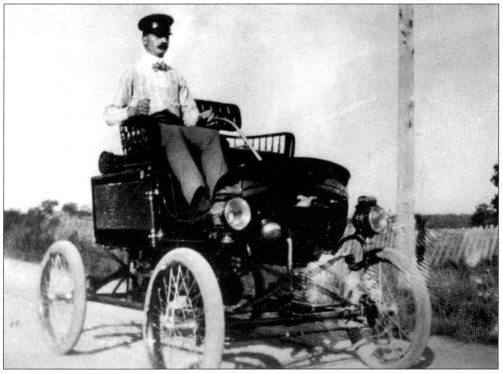

EDWARD STAEBLER IN A TOLEDO STEAMER, 1901. Staebler & Sons was the first automobile dealership in Ann Arbor. Edward's father, Michael Staebler, owned the American Hotel, which had a bicycle shop in one of its storefronts. In 1900, Edward talked his father into selling cars. On October 9, 1900, their first demonstration model arrived—a three-wheeled auto called a Trimoto. When it couldn't even make it up the hill from their house on Liberty Street to their store on Washington Street, they decided to exchange the car the following year for a Toledo Steamer. It didn't work much better and also didn't sell.

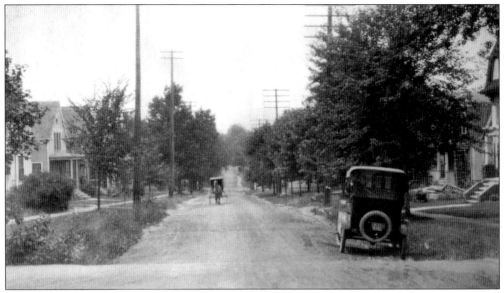

Huron Street at Main Street Looking West, c. 1915. Ann Arbor, in spite of being so close to Detroit, was fairly slow to embrace cars. In 1915, Huron Street still looked like a country lane as a lone car shared the road with a horse and buggy. "This is a peculiar town, our population is 18,000 and we have not over a dozen machines here. Half of those are used but very little," complained Edward Staebler to his automobile supplier in 1906.

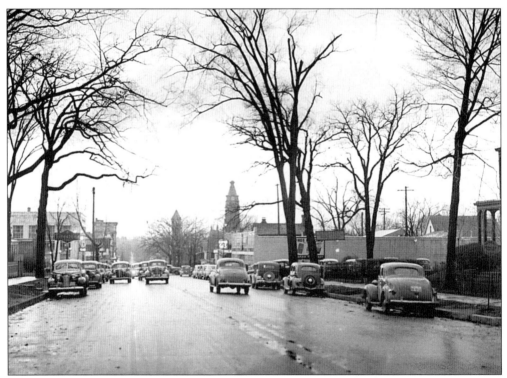

Huron Street Looking West from State Street, 1940. Twenty-five years, later Huron Street was the major artery through town, with gas stations and restaurants along the route.

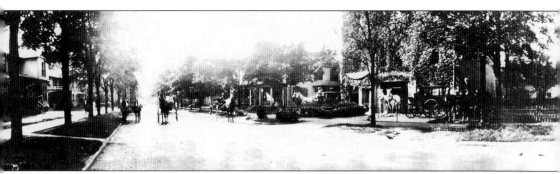

WALKER LIVERY, 515 EAST LIBERTY STREET LOOKING WEST, 1912. When this picture was taken, Walker's was the largest livery in the city, with 30 horses. Owner Adelbert B. Walker is in the center. The Arabian horses (right) were used for funerals; the large coach was used to carry the pallbearers.

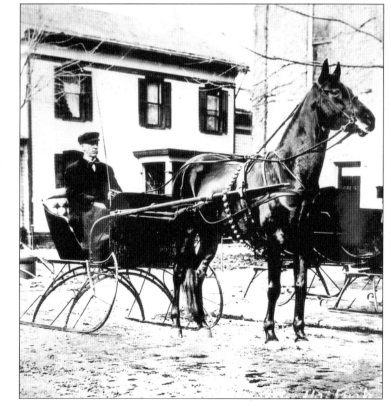

DRIVER LEW HAMMOND IN A WALKER CUTTER. In the winter, it was easier to travel in a light sleigh called a cutter, especially in the country where snow removal was more difficult. During the 1918 flu epidemic, Dr. Neil Gates was driven from patient to patient in a cutter, sleeping between patient visits because he was too busy to go home to his own bed.

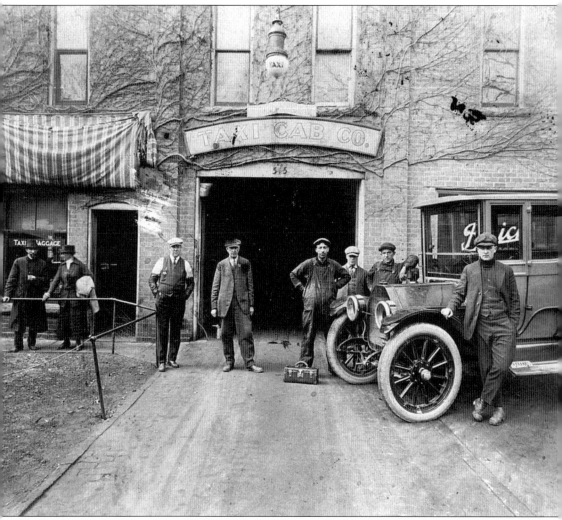

WALKER CAB COMPANY. In 1914, Walker auctioned off his horses and switched to cars. The City removed the hitching posts from the fronts of houses in 1922, although a few can still be found in older neighborhoods such as the Old West Side and the Old Fourth Ward. The last of the hansom cabs stopped service in 1924. Walker's building is now the site of the Liberty Square parking structure.

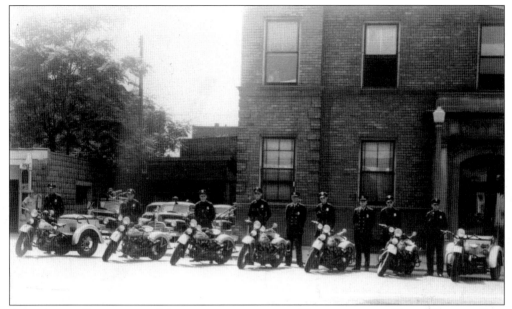

ANN ARBOR POLICE WITH MOTORCYCLES AT THEIR HEADQUARTERS, FIFTH AVENUE SIDE OF CITY HALL, 1940. In 1911, the AAPD purchased its first motorcycle from Staebler & Sons to enforce an ordinance enacted that year decreeing that cars could only go 10 miles per hour in the business district and 15 miles per hour in residential areas. The AAPD had previously rented horses and buggies as needed from either the Walker or Polhemus livery stables. If chasing a criminal, they would stop a passing horse and buggy and ask the driver for help. By the time this picture was taken, the police department had a fleet of motorcycles.

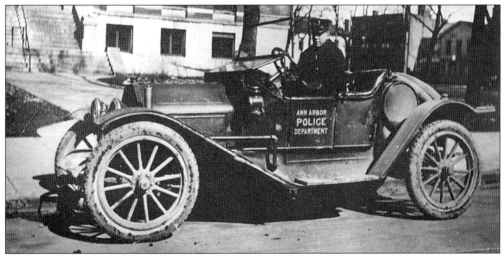

POLICEMAN EDWARD J. KUHN DRIVING THE DEPARTMENT'S FIRST CAR, 1914. Kuhn, who joined the department in 1910, was the first policeman to drive a patrol car, a Cutting made in Jackson. When the AAPD purchased the car, only one other officer besides Kuhn knew how to drive. On one occasion, Kuhn pursued and caught up with Robert Kempfert, whom he suspected of exceeding the ten-mile-per-hour speed limit. The case never made it to court because the police chief refused to believe that the REO that Kempfert was driving could go faster than eight miles per hour.

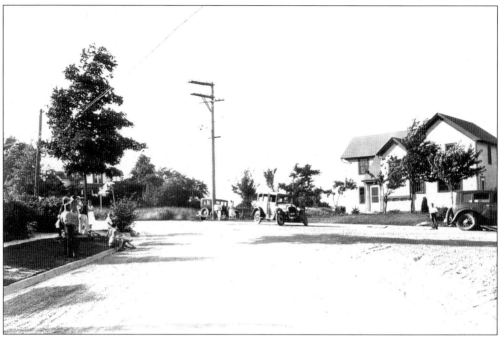

ACCIDENT AT SPRING STREET AND SUMMIT STREET. How two cars could run into each other when they had so much room is a puzzle, but accidents did occur even in the early days of automobile travel.

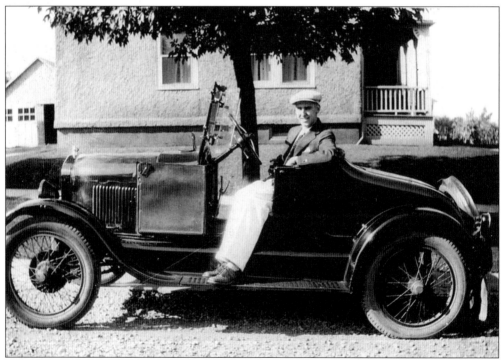

HENRY MICHELFELDER IN HIS MODEL T, 1931. First-time car owners like Henry Michelfelder loved to pose proudly for photos. Michelfelder is in front of his house at 314 Pauline Street.

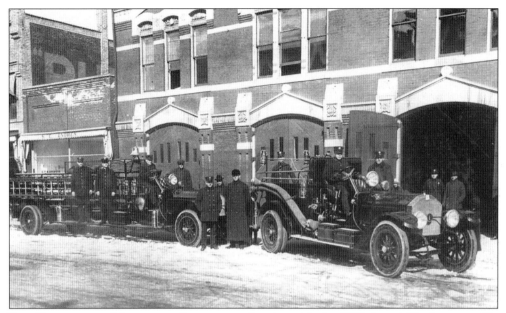

FIRE DEPARTMENT MOTORIZED EQUIPMENT. Starting with the 1903 Argo Mills fire, every big fire in town led to discussion of switching to motorized fire trucks. But Ann Arbor citizens were fond of horses and resisted the change, voting down a proposal to buy motorized vehicles as late as 1914. Finally in 1915, after a disastrous fire at Koch and Henne Furniture Store, the city bought a combination hose and engine truck and a motor service truck. The firemen used both horses and motorized fire trucks at first. Barney, Duke, and Jim, the last three fire horses, were finally sent to a farm to enjoy their retirement.

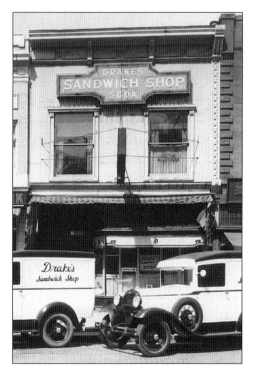

DRAKE'S DELIVERY TRUCKS, 709 NORTH UNIVERSITY AVENUE, 1929. Businesses also gradually began to switch to motorized vehicles. Varsity Laundry replaced its horses and wagons with Dodge trucks in 1913. Muehlig's Funeral Parlor waited until 1918 to switch and still used horses in bad weather. When Heusel Bakery switched to trucks, Fred Heusel's neighbor Elsa Ordway remembers hearing a driver call out "whoa" instead of using the brakes when pulling into the Heusel's driveway. When Drake's opened in 1929, it boasted state-of-the-art delivery trucks. Drake's was a favorite campus hangout for decades.

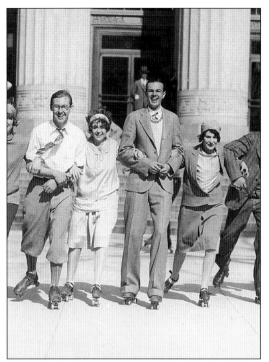

UNIVERSITY STUDENTS ROLLER SKATING AFTER 1927 STUDENT CAR BAN. Young people took to automobiles more quickly than their elders, but drove more recklessly, often in questionable cars. The town attempted to grapple with the problem in a 1924 ordinance, which decreed that only two people could sit in the front of a car; lap sitting was forbidden. But problems persisted and in 1927, the U of M banned all student driving. Students responded by roller skating everywhere and town kids soon joined in the fun. South University Avenue was closed to traffic at night while throngs of young people skated in the light of Japanese lanterns. "Stores were sold out of skates and kids became familiar with every piece of sidewalk, from the teeth chattering cement to the smooth slate walks on Forest Avenue," recalled a 1920s townie.

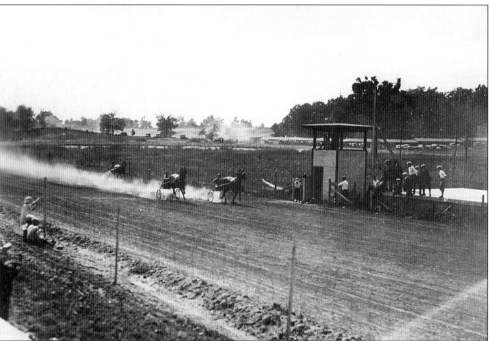

HARNESS HORSE RACING AT THE FAIRGROUNDS. As traveling by horse became a memory, the sport of horse racing gained in popularity. Between 1922 and 1944, horses raced at the fairgrounds (now Veterans Park), which was considered to have the best eighth-of-a-mile course in the state. The racing horses were stabled at the northwest corner of the fairgrounds. Guy Mullison ran a private riding stable at the southeast corner.

STAEBLER & SONS USED CARS, 119 WEST WASHINGTON STREET, c. 1930. The rise of motorized vehicles for every form of transportation spawned a whole new support industry designed to sell, repair, fuel, and park cars. By the 1930s, the Staeblers had switched entirely from bicycles to cars and had changed their hotel dining room to a Pontiac showroom. The rest of the town's car dealers were located downtown, such as Prochnow Buick on Ashley Street and William Brown Chevrolet on Huron Street. In 1964, Prochnow led the migration to the outskirts of town by moving to 3165 Washtenaw Avenue.

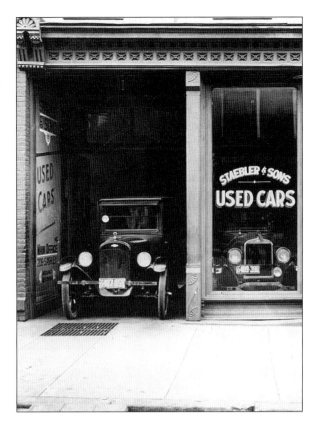

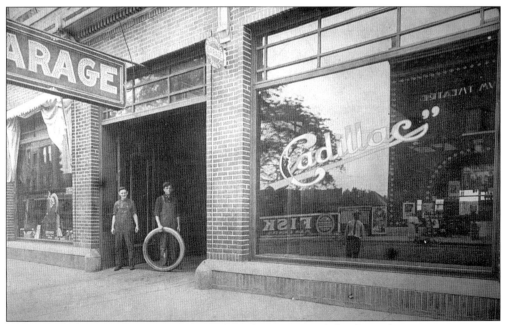

CADILLAC GARAGE, 327–329 SOUTH MAIN STREET, 1915. In the early years, even garages were located on Main Street. Note the reflection of the Orpheum Theater across the street.

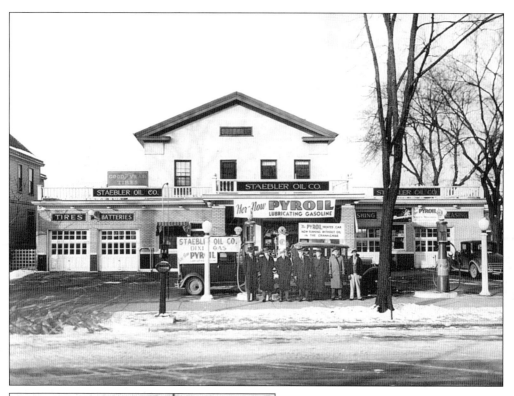

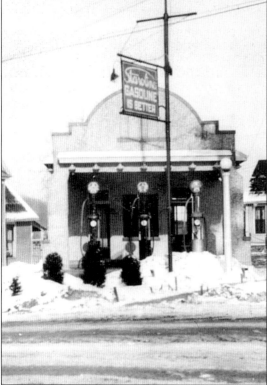

STAEBLER GAS STATION, 424 SOUTH MAIN STREET, 1921. Early gas station architecture ran the gamut from the sublime to the ridiculous. While the Staeblers used the old Philip Bach mansion for their first station, other gasoline entrepreneurs built little sheds. This led to howls of protest from people who did not want gas stations located in their neighborhoods. The site of Staebler's Gas Station is now part of the Ashley Mews townhouses.

HUNTER GAS STATION, 300 WEST HURON STREET, 1926. To counteract complaints, gas station owners began building more interesting structures that blended into or enhanced neighborhoods. A good example of this was the Hunter Brothers' Mediterranean-style station. Gas stations proliferated in Ann Arbor; it was not unusual for two or three stations to compete for business at the same intersection.

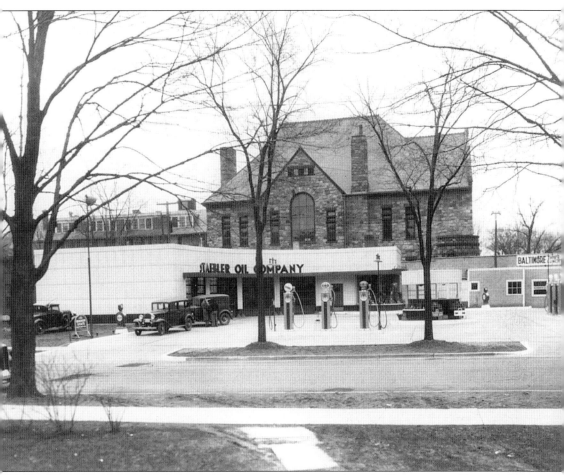

STAEBLER GAS STATION ON STATE STREET ACROSS FROM ANGELL HALL, 1933. Enameled-steel stations, sometimes called "ice boxes," became popular in the 1930s and 1940s. Locally, the Staeblers led the way by hiring Ann Arbor architect Pete Loree to design an enameled steel station for them. The U of M Administration building stands here now, blocking East Jefferson that once went through to State Street.

First Municipal Parking Lot, Corner of Washington Street and First Street. Opened in 1949, this parking structure—the first in Ann Arbor—is also believed to have been the first municipally owned parking structure in the world. Parking became a problem after World War II, when gas rationing ended and factories returned to car manufacturing. Meters were introduced in 1946; the proceeds were used for parking lots and for this parking structure. Mayor William Brown's Chevrolet dealership can be seen at the bottom left of the photo.

Four

THE TOWN EXPANDS

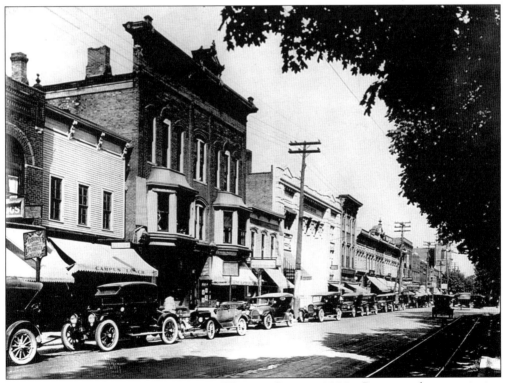

STATE STREET, LOOKING NORTH FROM WILLIAM STREET, 1920S. Businesses began springing up along the west side of State Street after 1886, when home delivery of mail made it easier to live farther from the post office downtown. State Street had become a full-fledged shopping area by the early 1900s.

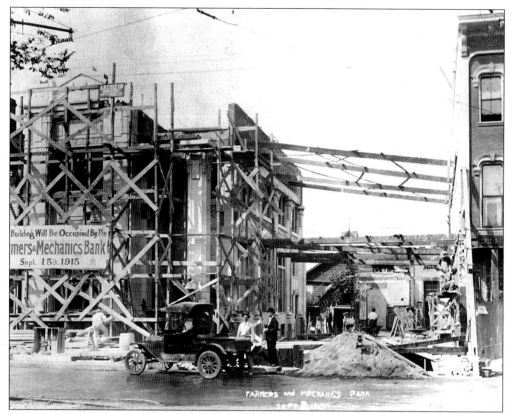

Building Will Be Occupied By The
mers & Mechanics Bank
Sept. 15th. 1915

FARMERS and MECHANICS BANK
SEPT.

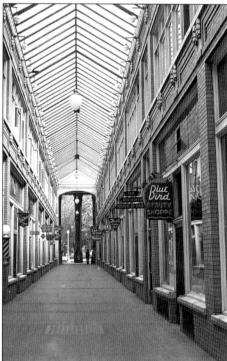

NICKELS ARCADE UNDER CONSTRUCTION, 1915. The brainchild of Thomas Nickels, who decided to build a European-style glass-roofed arcade where his father's meat market once stood, the Arcade signaled States Street's transformation from a shopping district that sold everyday products to one selling luxury items. Farmers and Mechanics Bank, lenders for the project, occupied the front anchor building. The architect was Herman Pipp, who also designed the Marchese Building, 319 South Main Street, and the old city hall. Nickel's house, which faced Maynard Street, can be seen in the back.

NICKELS ARCADE, INTERIOR, FACING STATE STREET. The first tenants sold luxury items such as flowers, jewelry, and candy.

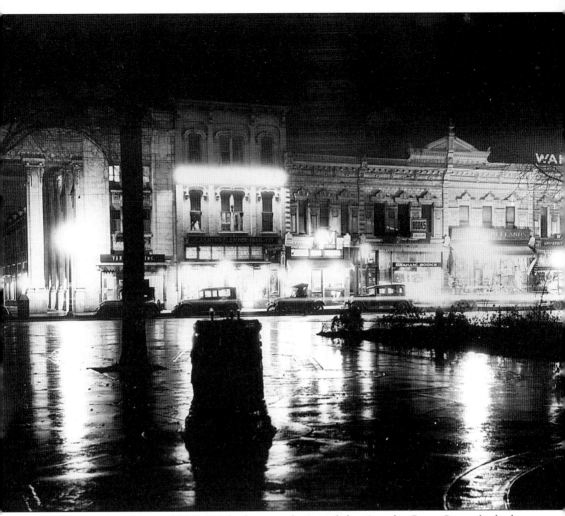

STATE STREET AT NIGHT, 1927. With the completion of the Arcade, State Street looked quite elegant, especially on a rainy night. The interurban tracks are discernable on the right.

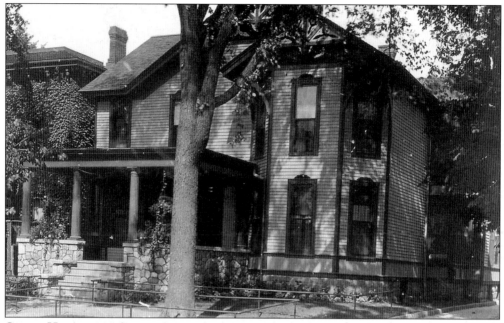

CHUBB HOUSE, 209 SOUTH STATE STREET. At the beginning of the 20th century, the east side of State Street was lined with private residences that were gradually transformed into commercial businesses. Chubb House, built as a family home, became a boarding house in 1902. Before the 1930s, when the University of Michigan began constructing large dormitories, Ann Arbor was a town of boarding houses. As Chubb's business increased, the owners extended the building to the sidewalk. In 1930, it became the Ritz Nightclub. In 2002, the original family house is still visible behind the store fronts that now occupy the street.

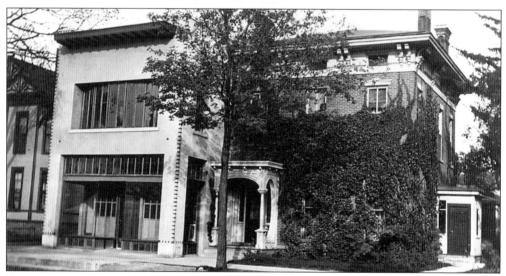

FOSTER'S ART HOUSE, 215 SOUTH STATE STREET. In 1914, Clarice and James Foster, who lived next door to Chubb's, added an addition, designed by U of M professor Emil Lorch, to the front of their Italianate house for their art store. Selling luxury items such as Rookwood pottery and imported brass, the Fosters catered to the same discerning clientele that shopped in the Arcade. The couple eventually added a tearoom in the front. A corner of Chubb's can be seen at left.

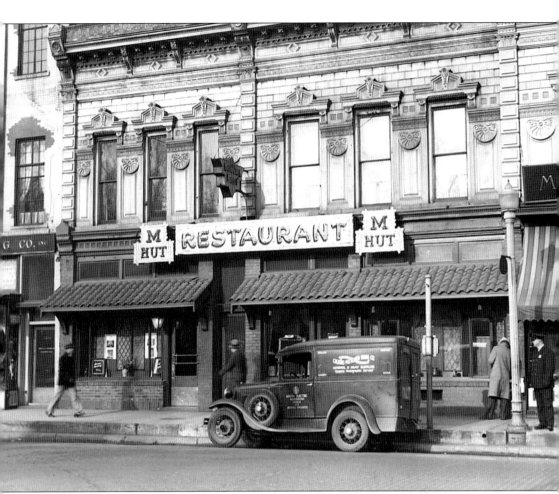

M-Hut Restaurant, 320–322 South State Street, mid-1930s. A student hangout, the M-Hut had space for dancing, a big craze that started in the 1920s during Prohibition. The streetscape was well established by then, although the uses for State Street buildings changed over the decades.

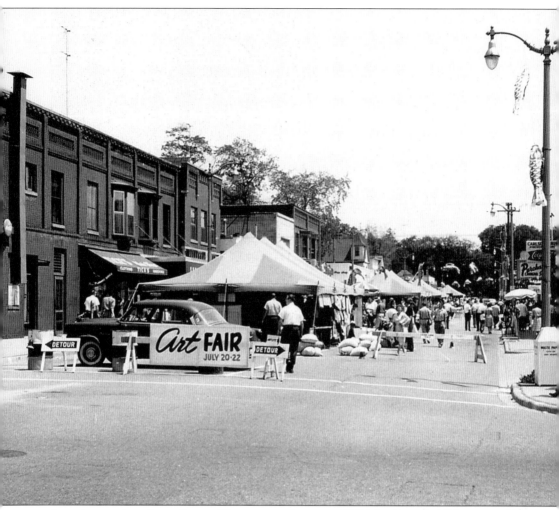

ANN ARBOR ART FAIR, SOUTH UNIVERSITY AVENUE, 1960. In the early 20th century, stores began opening on South university just east of campus. The Art Fair was started in 1960 by South University merchants as a lure for bargain days. Today, the Art Fair has spread to all of the town's central business districts; it is one of the biggest and best art fairs in the country.

FARMERS' MARKET, BACK OF COURTHOUSE, 1920s. The Ann Arbor Farmers' Market was organized in May 1919 to save farmers and consumers the cost of the middleman. Arriving by horse and wagon, farmers would back their wagons up to the curb on the Fourth Avenue side of the courthouse and then take their horses to a dairy barn on Miller Avenue at First Street. The market later spilled over onto Ann Street, and to the other side of Fourth Avenue in front of the old YMCA, which can be seen in the background. By the time this picture was taken, most farmers had switched to trucks.

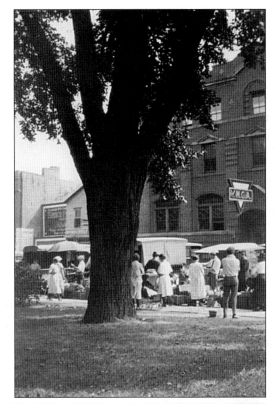

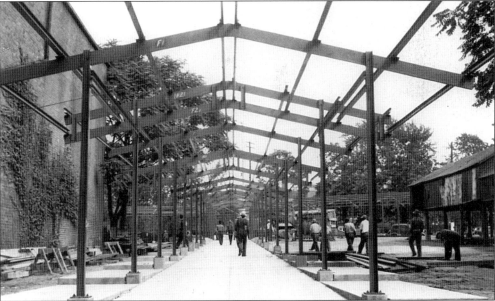

CONSTRUCTION OF FARMERS' MARKET ON DETROIT STREET, 1938–1940. In 1931, Gottlob Luick, former mayor and lumberyard owner, donated land for a new Farmers' Market. During the Depression, the farmers displayed their wares along the sidewalk and used the old lumber sheds for protection from the elements. WPA work teams developed the site in 1938, paving the walkways and adding a roof. Note the former lumber sheds on the right.

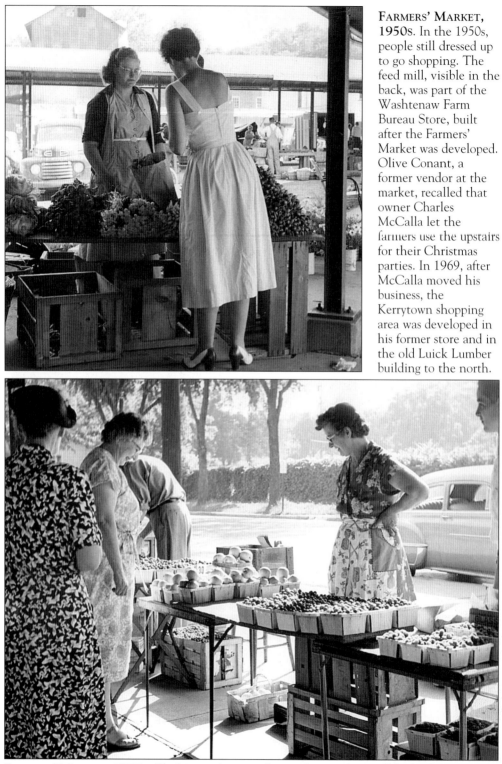

FARMERS' MARKET, 1950s. In the 1950s, people still dressed up to go shopping. The feed mill, visible in the back, was part of the Washtenaw Farm Bureau Store, built after the Farmers' Market was developed. Olive Conant, a former vendor at the market, recalled that owner Charles McCalla let the farmers use the upstairs for their Christmas parties. In 1969, after McCalla moved his business, the Kerrytown shopping area was developed in his former store and in the old Luick Lumber building to the north.

FARMERS' MARKET, 1950s. Clothing styles may change, but produce still looks the same.

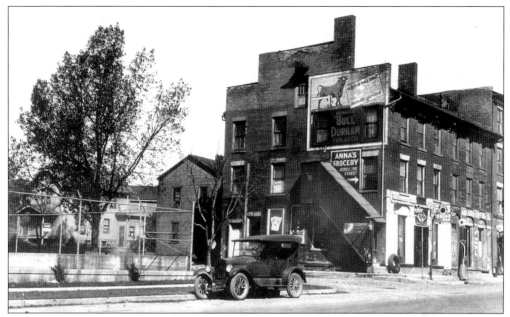

Anson Brown Building, 1001–1007 Broadway, 1920s. If Anson Brown, developer of the Lower Town settlement north of the Huron River, had not died in the 1834 cholera epidemic, this part of town might have appeared in the first section of this book as Ann Arbor's major shopping area. Although Brown's Exchange Block had long passed its prime in this picture, in 2002 it had the distinction of being the oldest commercial building still standing in Ann Arbor, proving once again that poverty is preservation's best friend.

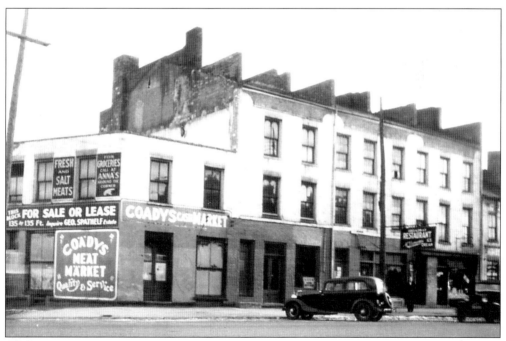

East Side of Broadway. Brown's shopping block on the east side of the street did not fare as well. It was demolished in 1959.

CORNER OF STATE STREET AND PACKARD STREET, 1920s. This corner still functions as a mini-shopping area for students who live south of campus. The building on the right was formerly an interurban stop. Once the edge of town, this area now connects the main campus with the athletic buildings. Malls made their local appearance after World War II, starting with Arborland in 1962, and followed by Briarwood Mall in 1973. Although civic leaders worried that the malls would harm downtown, they resisted drastic infrastructure changes, such as tearing down buildings for parking. Today, most of the practical stores have disappeared, but downtown Ann Arbor is bustling as people from all over southeast Michigan enjoy restaurants, galleries, and unusual shops.

Five

THE UNIVERSITY OF MICHIGAN

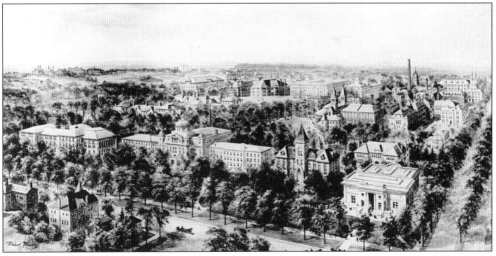

THE UNIVERSITY OF MICHIGAN, FACING STATE STREET, 1907 ENGRAVING. When this engraving was made, only the president's house and the observatory remained from the pre-Civil War campus. By the end of the 20th century, most of the buildings depicted here had, in turn, been replaced. Of the buildings shown facing the street, only Alumni Memorial Hall at right (now the art museum) is still there today. It looks a bit different because this engraving was done before the building was constructed. Today, the 21st century campus has spread far beyond the University's original 40 acres and includes a second campus to the north.

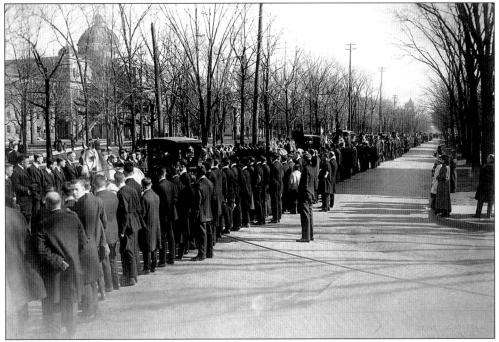

JAMES ANGELL'S FUNERAL PROCESSION ON STATE STREET, 1916. The death of James Angell, U of M president from 1871 to 1909, was deeply mourned by both town and gown. After his retirement, Angell had continued to teach international law and the history of treaties until he was too feeble to climb stairs. University Hall, the major classroom building, now replaced by Angell Hall, is in the background on the left.

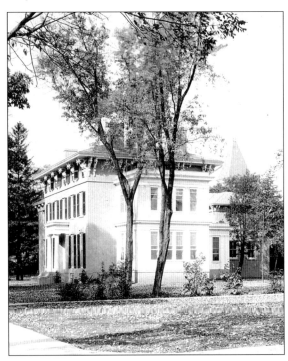

PRESIDENT'S HOUSE, 815 SOUTH UNIVERSITY AVENUE, C. 1920. The original 1841 campus contained four professors' houses. The house that was available when Henry Philip Tappan, the first president of the U of M, came to town in 1852 is still the president's house. Originally a simple two-story structure, it has been updated and improved by Tappan's successors. President Marion LeRoy Burton (1920–1925) added a sun parlor with a sleeping porch above it, enclosed the back porch for a dining area, and had a garage built. In the 1920s, garages were going up all over town.

DETROIT OBSERVATORY, 1398 EAST ANN STREET, 1920s. By the 1920s, the observatory had expanded to include a director's house (right) and a classroom building with a second dome (left) to hold the 37-inch reflector telescope. Both buildings were later removed. After the University Hospital went up across the street, and Couzens and Alice Lloyd halls were constructed on either side of the observatory, in addition to the power plant soon constructed nearby, smoke and electric lighting from these buildings made serious astronomical research impossible. Unused or underused for many years, the original 1854 observatory was completely restored in 1997. The Detroit Observatory is now the oldest observatory in America with its original instruments still intact in their original mounts.

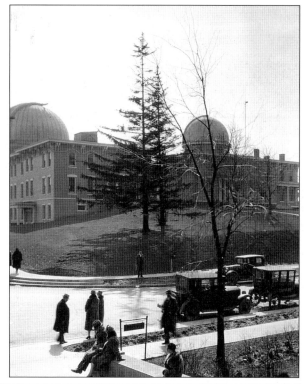

SOUTH UNIVERSITY AVENUE, LOOKING WEST TO STATE STREET, 1922. During the early-20th-century construction boom, the campus overflowed into neighborhoods surrounding the campus. This row of houses was torn down for the Law Quad.

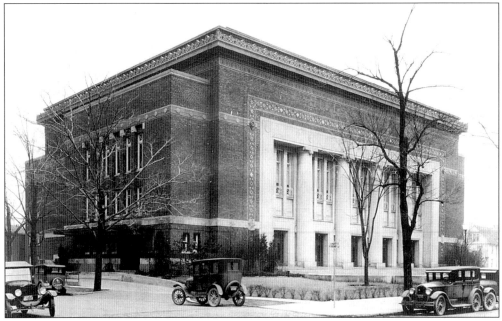

HILL AUDITORIUM, 1918. When Alexander Winchell's octagonal house was demolished to make way for Hill Auditorium in 1913, it was the first time the University had taken advantage of the "right of eminent domain" provision in the 1908 constitution. Designed by Albert Kahn, Hill Auditorium shows the influence of Chicago architect Louis Sullivan. Both town and gown continue to enjoy attending events at Hill, where most of the 20th century's leading classical musicians, including Enrico Caruso and Leonard Bernstein, have performed.

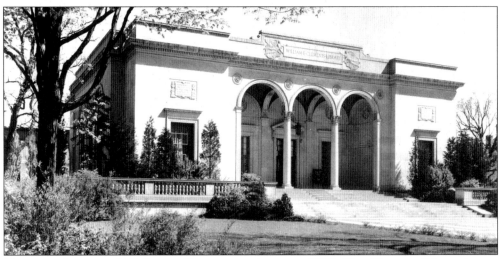

CLEMENTS LIBRARY, 909 SOUTH UNIVERSITY AVENUE, 1927. The Clements Library houses American history documents from Columbus's day through the Civil War era. Also an Albert Kahn building, it was designed in a Renaissance style to pay tribute to the era of the great explorers and cartographers who opened the Americas. The building was funded and the nucleus of its collection donated by regent and U of M alumnus William Clements. While studying under U of M English professor Moses Coit Tyler, Clements developed an interest in Americana. Tyler was credited with awakening the nation to the serious study of its own literature.

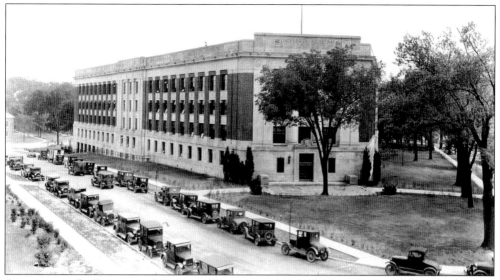

ALEXANDER G. RUTHVEN MUSEUMS BUILDING, 1109 GEDDES AVENUE, BACKING ONTO NORTH UNIVERSITY AND WASHTENAW AVENUE, 1930S. Built in 1928, the public part of this building is the Exhibit Museum, which displays natural history artifacts from the U of M's vast collection. This is another one of Kahn's seventeen designs for the U of M campus; the building's large windows and flexible interior space are hallmarks of Kahn's many factory designs. The trademark pumas, a WPA project by sculptor Carlton Angell, were not yet added when the picture was taken. The street on the left no longer exists.

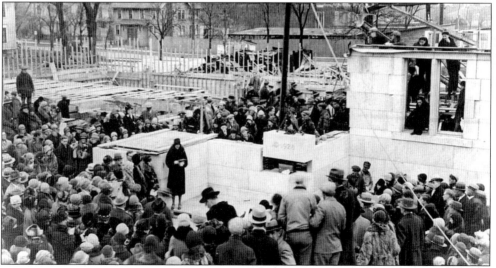

WOMEN'S LEAGUE GROUNDBREAKING, MARCH 29, 1928. In the 1920s, women studying at the University of Michigan decided that they needed a place of their own similar to the mens' Michigan Union. The women were given land by the regents, but had to raise the money for the building themselves. Eliza Mosher, U of M's first dean of women, turned the first shovel of dirt at the groundbreaking. The cornerstone was filled with items that the women had sold to raise funds for the building. The architects for the Michigan Union, Irving and Allan Pond, designed the Women's League in a similar but more graceful style. Note the presence of homes on Fletcher Street in the background, most likely boarding and rooming houses.

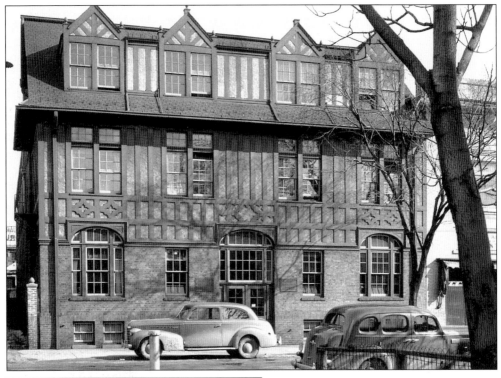

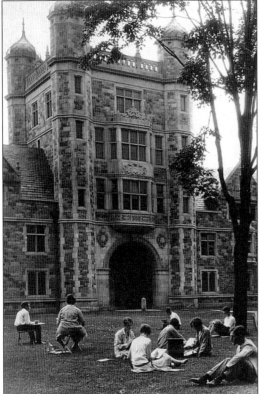

SCHOOL OF MUSIC, 325 MAYNARD STREET. Originally a private school, the School of Music became part of the U of M in 1929. Charles Sink, president of the University Musical Society, continued as president of the music school, while school director Earl Moore was the de facto dean. The music school remained next to the Nickels Arcade until it moved to North Campus in 1964.

ART CLASS IN THE UNIVERSITY OF MICHIGAN LAW SCHOOL COURTYARD, 1930S. The Law Quad was built between 1923 and 1933 by York and Sawyer in a style reminiscent of the Tudor Gothic colleges of Cambridge and Oxford universities. It is still considered one of the jewels of campus architecture.

RACKHAM SCHOOL OF GRADUATE STUDIES, AND BURTON MEMORIAL TOWER, 1938. Although building slowed down during the Depression, two notable additions were made to the campus during this time. Albert Kahn's ten-story Burton Tower, reminiscent of an Italian campanile, is a memorial to U of M president Marion LeRoy Burton, who died in 1925. Charles Baird, former U of M athletic director, paid for the 53 bronze bells in the carillon. The Rackham Building, designed in the popular art deco style by Smith, Hinchman & Grylls, is a memorial to Horace Rackham, Ford Motor Company lawyer and investor, who died in 1933. Thirty buildings were removed from the site to make way for the Rackham Building.

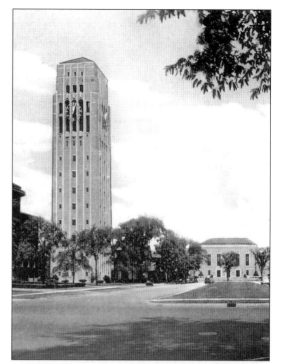

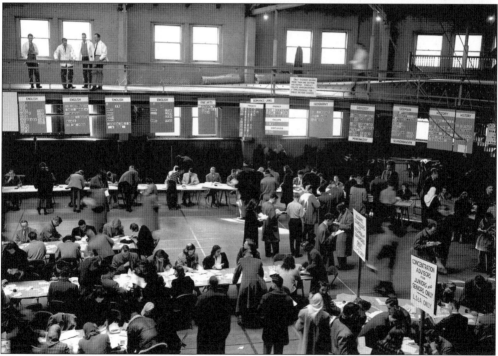

STUDENT REGISTRATION, 1948. Before the days of computers, students stood in long lines at Waterman Gymnasium to register for classes. A large open space, Waterman was commandeered for many different purposes, from housing World War I soldiers to campus-wide dances like the J-Hop.

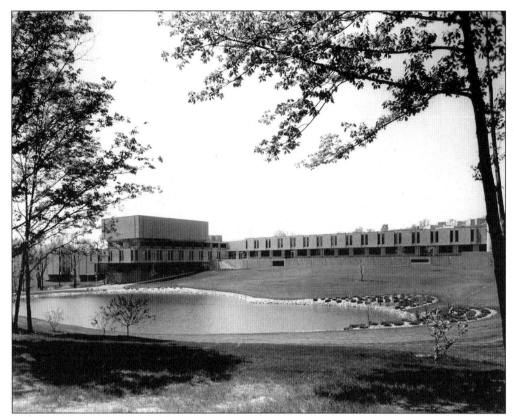

SCHOOL OF MUSIC, NORTH CAMPUS, 1964. In 1950, to avoid the continuing encroachment of residential neighborhoods, the U of M regents bought land for a second campus north of town. Well-known architect Eero Saarinen was hired to develop a North Campus master plan. He also designed a new music school building that allowed the music school to consolidate operations from 12 separate locations.

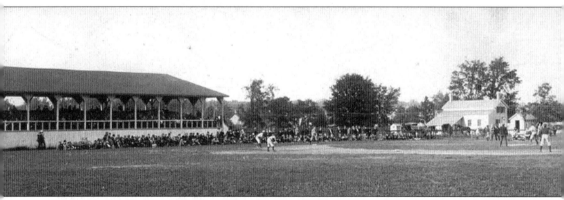

BASEBALL AT REGENTS FIELD, 1900. Regents Field, a 10-acre site on the west side of State Street south of campus, was used as both a baseball diamond and a football field. It was the place where "point-a-minute" football coach Fielding Yost made his mark after arriving at U of M in 1901. Yost took his team to the first Rose Bowl just one year after he arrived. The Wolverines won easily, although Yost could only afford to bring 15 players along, and had time for only one practice after the team's 4-day cross-country train trip.

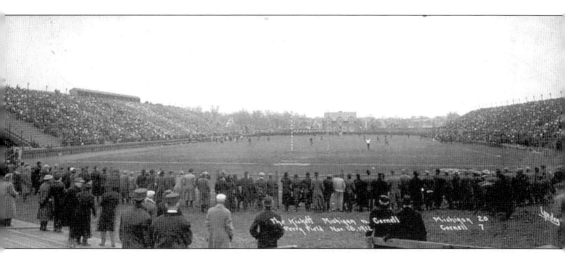

KICKOFF FOR THE CORNELL FOOTBALL GAME AT FERRY FIELD, 1912. In 1906, Regents Field was extended by 17 acres with money donated by Dexter Ferry, a wealthy Detroit seed merchant. Track, tennis, hockey, and soccer were also played here.

THE UNIVERSITY OF MICHIGAN STADIUM, UNDER CONSTRUCTION, 1926. Neighborhood kids watched as the Miller Farm was transformed into a huge football stadium. University Regents had informed Coach Yost that "amateur college contests should not be transformed into public spectacles," but their warning came too late. A less-than-capacity crowd attended the first game, October 1, 1927, against Ohio Wesleyan, but on October 22, a reported 85,000 squeezed in to watch U of M beat Ohio State 21–0, in what was called the Dedication Game.

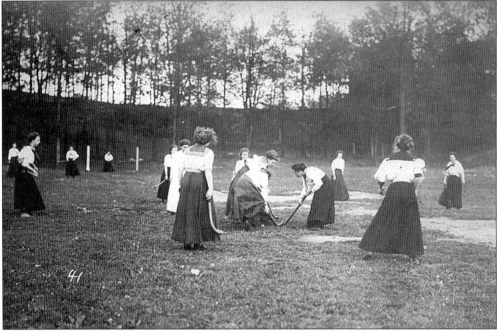

WOMEN PLAYING FIELD HOCKEY ON PALMER FIELD, C. 1905. Although women's athletics didn't have the same infrastructure or receive as much attention as men's athletics, women still enjoyed playing sports, even in their long skirts. Today, Palmer Field is lined with women's dorms.

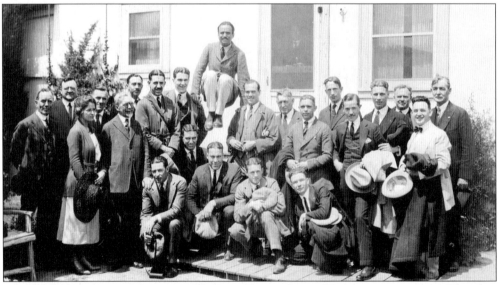

THE UNIVERSITY OF MICHIGAN TRACK TEAM GOES HOLLYWOOD, 1921. The first intercollegiate track meet was held in 1893. By the 1920s, track was a big enough sport that even Hollywood stars took an interest in it. After traveling west to compete with western universities, the U of M track team was entertained by actor Douglas Fairbanks. He treated them to a Wild West show and showed them scenes from his forthcoming production of *The Three Musketeers*. The U of M athletes put on an impromptu field day, with Fairbanks acting as referee. The group included 15 athletes, their coach, and their manager.

Six

GOVERNMENT, SERVICES, AND INDUSTRY

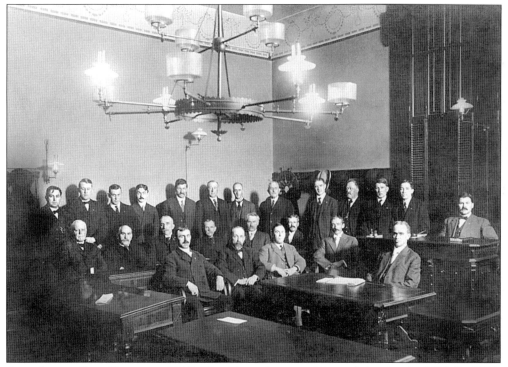

ANN ARBOR CITY COUNCIL, 1909. City Council was a white male bastion in 1909. By 2002, council was divided between the sexes and included minorities. The town's first black mayor was Albert Wheeler, elected in 1975. The first woman mayor was Elizabeth Brater (1991–1993). Note the gas lamp.

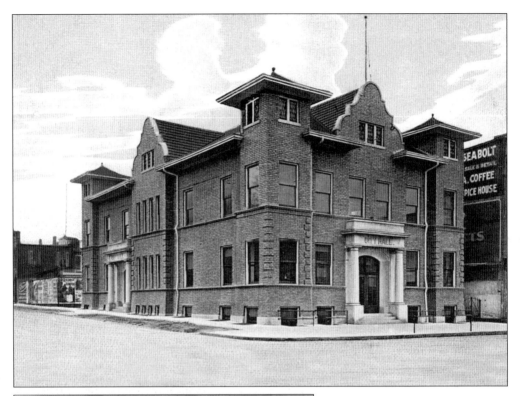

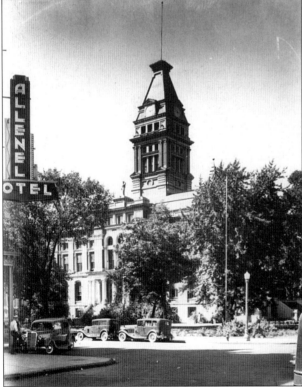

OLD CITY HALL, BUILT 1907.
By the beginning of the 20th century, municipal services in Ann Arbor had grown so extensive that an entire building was needed to house them. Designed by Herman Pipp, who also served on city council, the new building stood on the southwest corner of Huron Street and Fifth Avenue, kitty-corner from the present city hall.

COUNTY COURTHOUSE, 1930s.
The 1877 courthouse covered a square block bounded by Main Street, Huron Street, Fourth Avenue, and Ann Street. It continued to be the center of town until it was torn down in 1956. The Allenel, the town's major hotel, was located just across the street at Huron Street and Fourth Avenue.

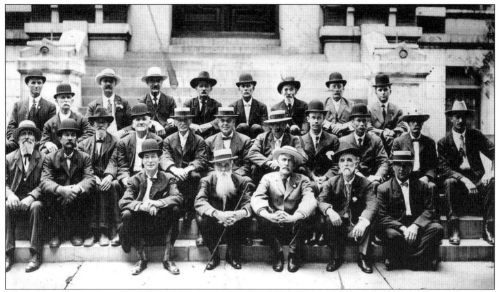

BOARD OF SUPERVISORS ON THE COURTHOUSE STEPS, 1910. The large board consisted of a representative from each of the 20 townships in the county plus representatives of each of the cities. In 1969, electoral reform changed the formula so that a board of commissioners was elected by districts in order to represent equal numbers of people. Like their counterparts on city council, all the members of the 1910 board of supervisors were male.

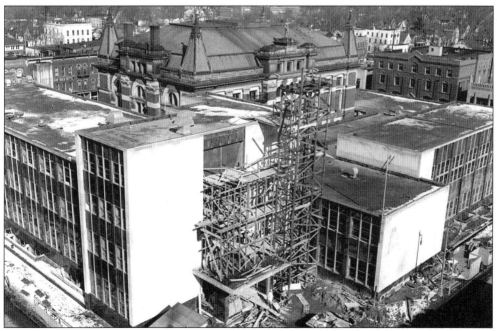

NEW COUNTY COURTHOUSE, UNDER CONSTRUCTION, 1956. In 1955, the voters approved a bond issue to build a new courthouse. Ypsilanti architect Ralph Gerganoff devised a clever way to build around the old courthouse, which not only avoided the problem of having to move twice but also allowed the county to continue to use the land originally donated by Ann Arbor co-founder John Allen. The old courthouse was torn down; the space is now used for parking.

New City Hall, Under Construction, 100 North Fifth Avenue, 1960. The new city hall, still in use today, was design by Midland architect Alden Dow. Between 1932 and 1970, Dow designed eighteen buildings in Ann Arbor, including five for the U of M. His design for city hall is often described as an upside-down wedding cake. Balconies with trees were a trademark of Dow's design, but did not always work in Michigan's climate. Today, the areas meant for trees are filled with stones. The sunny and open work areas, another Dow feature, have been cobbled into smaller workspaces over the years, as city hall has become more crowded.

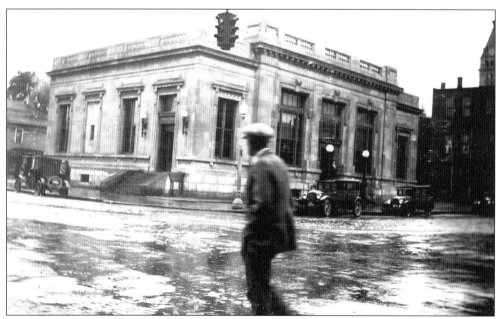

Post Office, 220 North Main Street, 1920s. In 1909, the federal government built Ann Arbor a lovely beaux-arts post office using a plan replicated around the country. A careful 1933 addition enlarged the original three protruding bays to five without altering the look of the building. Washtenaw County purchased the building in 1978 and still uses it for administrative offices.

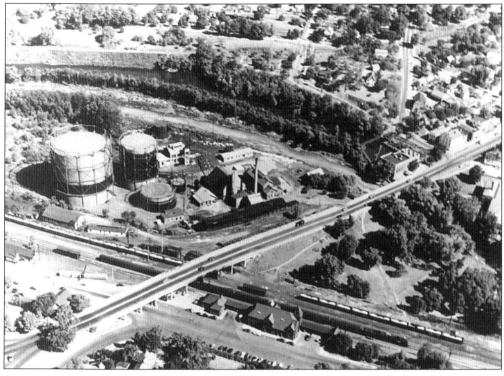

MichCon, 841 Broadway, North Side of Railroad Tracks Near the Broadway Bridge. The gas company produced gas until the 1940s, when it began using piped gas. Even after the age of water-powered mills ended, the area near the Huron River remained industrial.

Michigan Bell Telephone Company Building, 315–323 East Washington Street. In 1912, the town's two telephone companies, State Telephone and Michigan Bell, merged. At first the company rented offices, but in 1925 it moved into its own building, a beautiful beaux-arts structure with terracotta tiles, still in use today.

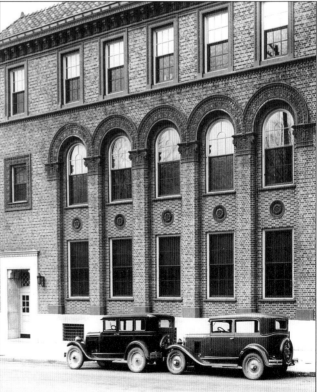

ARGO MILL FIRE, 1903. Flour was very flammable and mills frequently burned down, as the Argo Mill did in February of 1903. The owner, the Michigan Milling Company, built the Argo Powerhouse on the site to supply power for its two other mills. In 1905, Eastern Michigan Edison Company (today Detroit Edison) purchased the plant.

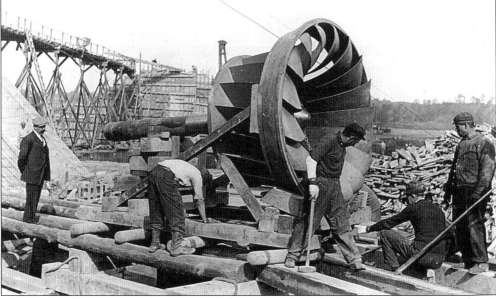

INSTALLING THE TURBINE AT BARTON DAM AND POWERHOUSE, 1912. In addition to the Argo site, Edison bought mills, dams, and water rights all along the Huron River to create an electric-power monopoly in southeast Michigan. West of Ann Arbor, Edison bought water rights near the ghost town of Barton, and east of town, the company bought an old dam and a mill at the hamlet of Geddesburg. The company hired U of M engineering professor Gardner S. Williams to do the technical work and U of M architecture professor Emil Lorch to design the buildings. Damming or re-damming the river at each of these sites, they created ponds that citizens welcomed both for recreational use and as a power source that reduced the smokiness of Ann Arbor's coal-infested air. At that time, no one worried about lowered water quality or fewer varieties of fish.

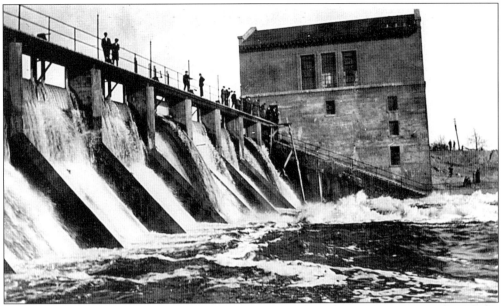

BARTON DAM AND POWERHOUSE, 1913. The first of the Edison's Huron River dams to be completed, Barton was an impressive achievement.

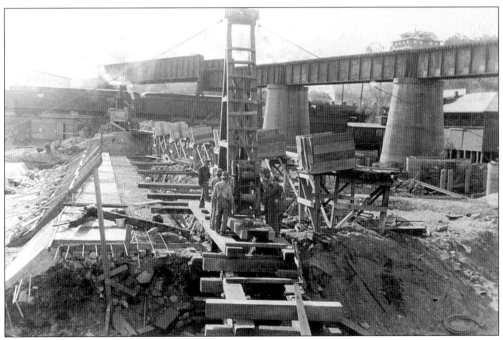

BUILDING ARGO DAM, 1914. When they got to Argo, the Edison workmen rebuilt a dam that was already there, near the Ann Arbor Railroad overpass.

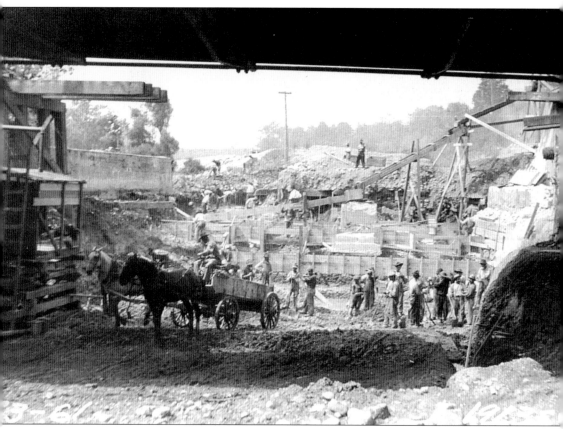

MEN AND HORSES AT WORK ON ARGO DAM, 1914. Without the aid of the modern equipment we take for granted today, considerable horsepower and manpower were needed to build the dams.

BRIDGE AND RAILROAD TRACKS LEADING TO THE ARGO POWER STATION, 1914. The tracks were a spur connecting Argo Mills and the Ann Arbor Agricultural Works, on the southeast corner of the bridge, with the main Michigan Central line across the river. They were also useful in transporting materials for the power station.

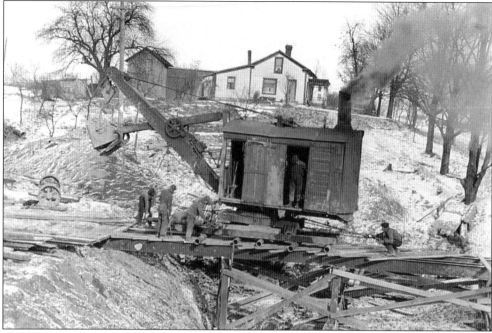

GEDDES DAM, 1918. Work on all of the dams was done with the aid of a "Mike Mulligan" type of steam shovel.

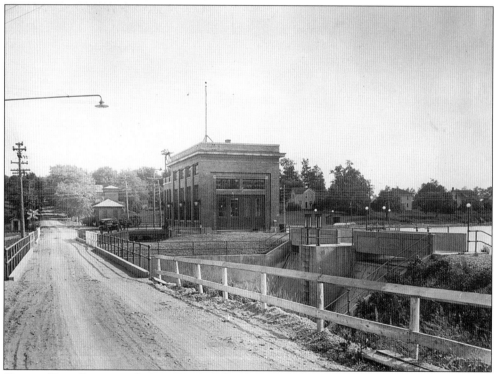

GEDDES DAM LOOKING SOUTH, 1919. The dam is no longer used as a source of power, but Gallup Park visitors enjoy its pond.

BARTON HILLS, 1927. Edison created a company called Huron Farms to oversee the land it had acquired while buying up water rights along the Huron River. To demonstrate how electricity could be used in agriculture, Huron Farms set up several model farms under the direction of William Underdown, including one on Whitmore Lake Road. The company also built a vacation spot for female employees, Vivienne Farms (now the site of Heartland Healthcare Center) on Huron River Drive, and the Barton Hills subdivision. Laid out on the north side of Barton Pond, the most beautiful of the newly created ponds, Barton Hills' first resident was Edison president Alexander Dow, who bought the first lot for $1 in 1919.

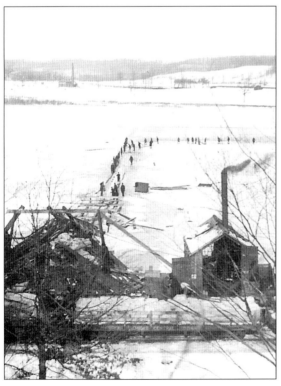

CUTTING ICE ON THE HURON RIVER. In 1909, there were six ice dealers in Ann Arbor. They harvested ice either near the dams on the Huron River or at Whitmore Lake, using horse-drawn plows. After 1909, manufactured or "artificial" ice competed with real ice. The industry died out after home refrigerators became more common in the 1930s and 1940s.

85

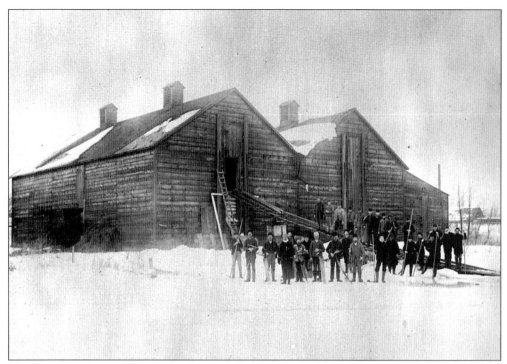

ICE HOUSE ON THE HURON RIVER, NEAR ARGO POND. The harvested ice was stored in icehouses near the river. It was delivered to private homes for iceboxes as well as to restaurants, butcher shops, saloons, and beverage companies. Customers left cards in their windows indicating how many pounds they needed. Ice truck drivers were popular with the children on their routes because they gave them slivers of ice to suck on in hot weather.

ALLEN'S CREEK FLOODING BETWEEN 601 AND 523 WEST WASHINGTON STREET, JULY 7, 1902. Allen's Creek flows north through town roughly along the Ann Arbor Railroad tracks (the route for the track was likely chosen to take advantage of the flat land) and empties into the Huron River. The creek was important in the early days of the town, when it was a mill and industrial site. By the 1920s, Allen's Creek, which had become a nuisance because of its periodic flooding, was sent underground in a pipe.

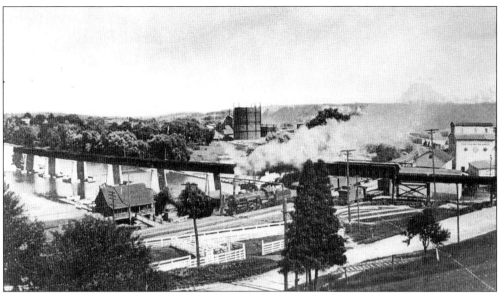

ANN ARBOR RAILROAD TRESTLE ABOVE THE ARGO DAM, C. 1905. The land along the Huron River was heavily industrial, but the presence of the Tessmer's boathouse (the building with the curved roof to the left of the railroad bridge) presages the change to recreational use later in the century.

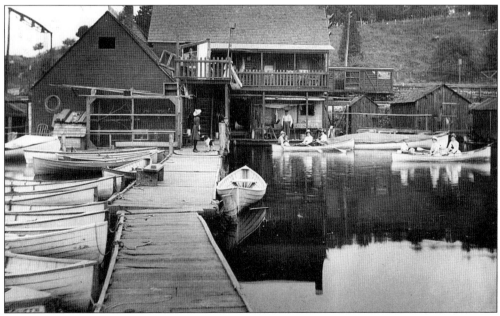

UNIVERSITY OF MICHIGAN AND HURON RIVER BOAT LIVERY, NORTH MAIN STREET BY THE ANN ARBOR RAILROAD BRIDGE. Between 1901 and 1916, Paul and Fredericka Tessmer operated the boat livery, renting rowboats and canoes and storing other people's boats. "For a Quiet Sunday Afternoon, Go Up the Huron. For the Pleasures of a Moonlight Eve, Go Up the Huron," proclaimed a 1908 advertisement. After Argo Dam was completed, Edison donated land on the other side of the river, just north of the dam, for the same use. In 1916, the livery moved and was operated by William Saunders; today the city runs a canoe rental on the same site.

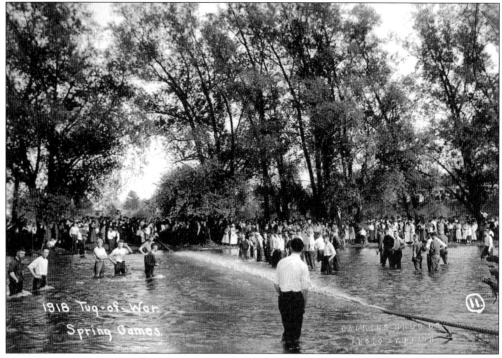

TUG-OF-WAR BETWEEN UNIVERSITY OF MICHIGAN CLASSES, 1918. A long-standing U of M tradition was the annual freshman versus sophomore tug-of-war held every spring on the Huron River.

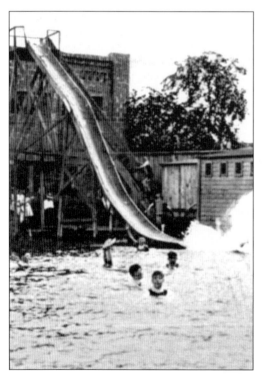

MAKING A SPLASH AT WEINBERG'S SWIMMING POOL, FIFTH AVENUE AT HILL STREET, C. 1914. At the end of the 19th century, Fred Weinberg developed a pool/ice rink for the city's youth by using natural springs on his property that ran parallel to Allen's Creek. The swimming pool was a rather primitive affair; Weinberg's nephew, Jonas Otto, earned spending money pulling out frogs. Around 1909, Weinberg added a cement bottom to the pool and built a coliseum next to it for indoor skating. U of M's first hockey game was played at the coliseum in 1920.

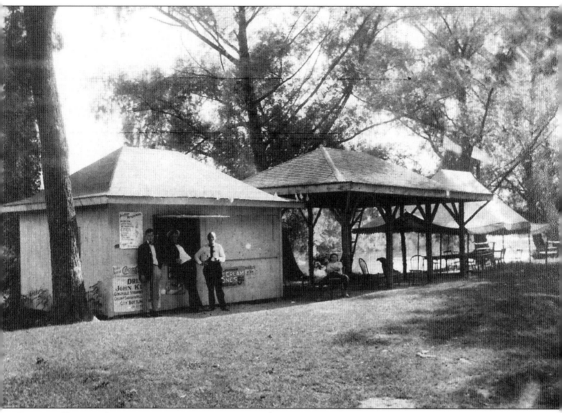

ISLAND DRIVE CONCESSION STAND. In 1905, the city organized the first parks commission at the urging of U of M botany professor George Burns, who was an early enthusiast of city planning. One of Burns's first projects was to develop the land behind the Michigan Central station into a river park like the hugely popular Island Drive Park, shown above. The biggest addition of river parkland came in 1963, when the city bought Detroit Edison's Huron River holdings after passing a bond issue to finance the purchase.

NICHOLS ARBORETUM BEFORE DEVELOPMENT, EARLY 20TH CENTURY. In 1906, George Burns convinced William Nichols to donate 27 acres on the outskirts of town to the U of M. Nichols had farmed the land to help pay his U of M tuition in the 1880s. Burns then convinced the city to add 23 acres along the river, creating a park owned by both the city and the U of M. In 1940, Detroit Edison added 30 acres of land, named Dow Prairie, in memory of the late Edison president Alexander Dow. O.C. Simonds, founder of the U of M's Department of Landscape Design, planned the layout.

Eight

ANN ARBOR
AND THE WORLD

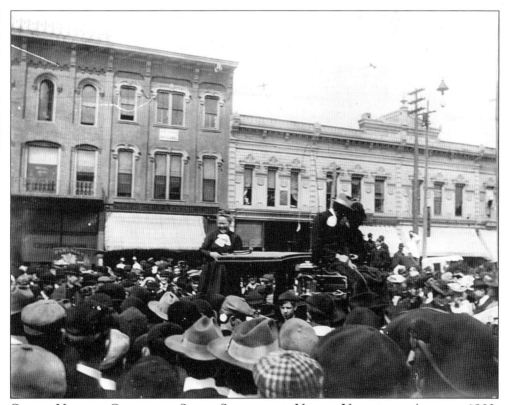

CARRIE NATION, CORNER OF STATE STREET AND NORTH UNIVERSITY AVENUE, 1902.
Prohibitionist Carrie Nation came through Ann Arbor as part of a national lecture tour. Nation
had gained fame in her home state of Kansas when she enforced its Prohibition laws by
invading speakeasies and shattering bottles with her hatchet. A member of the Ann Arbor
crowd, made up mainly of students, passed her a whiskey flask and asked her to smash it. The
crowd drew back as the horrible fumes wafted out; the bottle was filled with hydrogen sulfide!

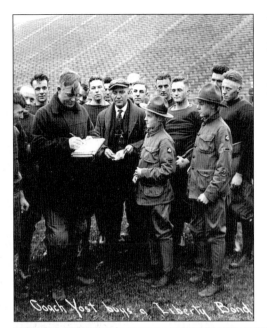

FOOTBALL COACH FIELDING YOST BUYING A LIBERTY BOND FROM BOY SCOUT TROOP FOUR, 1917. After the United States entered World War I on April 7, 1917, civilians mobilized to help the war effort. The U of M President's House, empty after the death of James Angell, was turned into the Red Cross Headquarters, where co-eds helped wind bandages. Alumni Hall (today the art museum) was converted into a Hostess House maintained by the women of the town so that families could visit with trainees stationed in Ann Arbor. Yost set a good example of civilian assistance by buying a liberty bond.

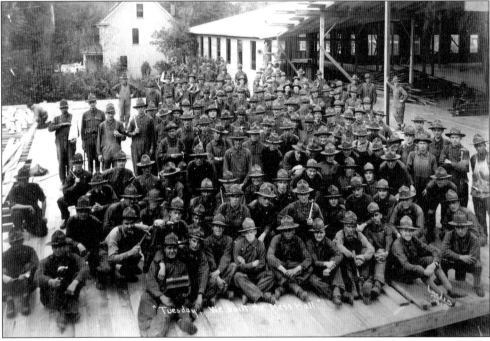

STUDENT ARMY TRAINING CORPS AT THE UNFINISHED MICHIGAN UNION, 1918. At the beginning of the war, U of M agreed to train non-university draftees in skills such as gunsmithing, carpentry, and mechanics. The Student Army Training Corps was later organized to allow college students to study and train at the same time, pending transfer to officer's training camp. When both programs merged, the campus became very crowded with 3,750 trainees on site at one time. The uncompleted Michigan Union, for which ground had been broken in 1916, served as a mess hall for the entire group and barracks for 400. Waterman Gym and 35 fraternities housed the rest.

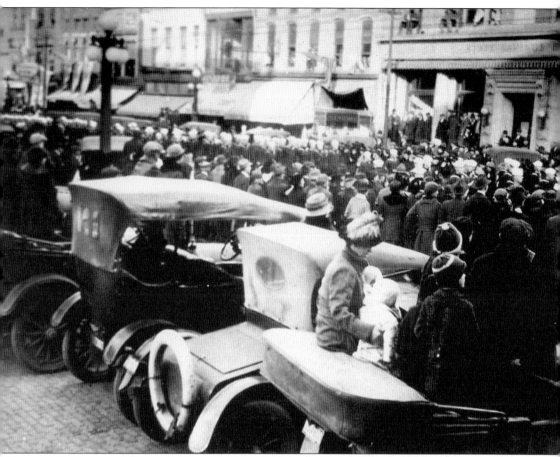

Family Watching Armistice Parade from Their Car. News of the November 11, 1918, armistice reached Ann Arbor in the middle of the night, and soon the entire town was awakened. An extra edition of the daily paper was printed, and newsboys hit the street yelling "extra, extra." Judge Sample rang the courthouse bell, Mayor Wurster sent the fire truck clanging through town, church bells rang, and U of M Regent Beal instructed the university to blow its fire whistle. By 4 a.m., there was an enormous bonfire at Main and Huron Streets; before dawn, people from nearby rural areas began pouring in to town. At 2 p.m., the official parade, featuring military and civic bands and every known organization, marched three miles, ending at Hill Auditorium with a songfest.

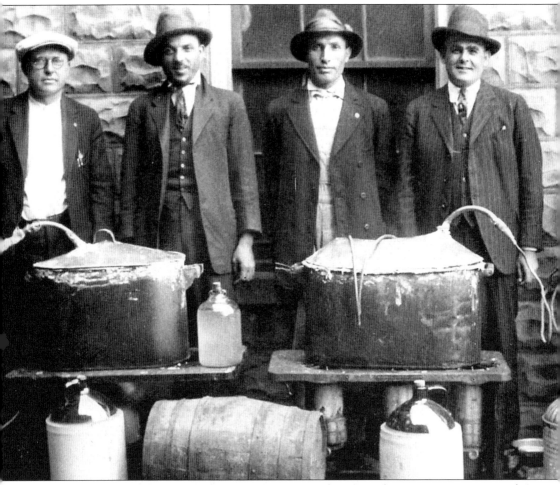

BOOTLEGGERS SHOW OFF THEIR EQUIPMENT. In the years after Carrie Nation visited Ann Arbor, the city became more supportive of Prohibition, and voted in favor of the law, which went into effect in 1918. Although some managed to have fun without liquor, hanging out at ice cream parlors and joining the 1920s dance craze, many still enjoyed contraband refreshment. This picture is from the collection of Ambrose Pack, Washtenaw County sheriff from 1919 to 1922. Prohibition ended in 1933.

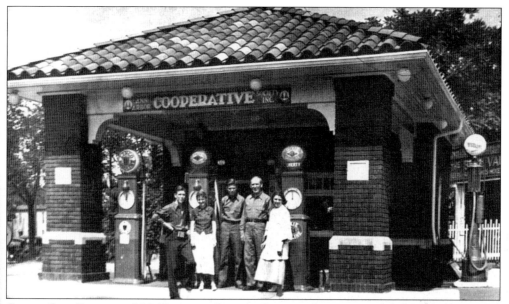

CO-OP GAS STATION, 300 DETROIT STREET. Because the presence of the U of M meant regular paychecks, Ann Arbor weathered the Depression better than some communities, but there were still many that had trouble making ends met. In 1936, a group of citizens organized a co-op gas station and grocery store to offer an alternative to capitalism in distributing the necessities of life. The building, with several additions, is now Argierio's Italian restaurant.

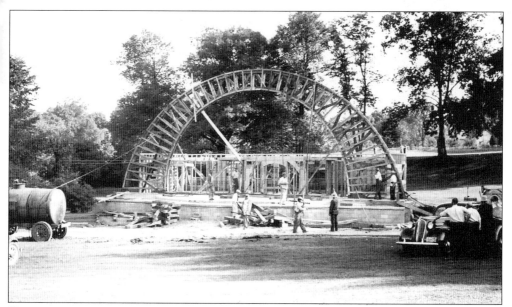

CONSTRUCTING THE BAND SHELL AT WEST PARK. Between 1933 and 1940, the federal government, particularly the Works Progress Administration (WPA), helped provide relief from the worst effects of the Depression by funding public improvement projects such as a farmers' market, school additions, and a municipal beach clean up. The band shell, which the WPA built at West Park, is still being used for summer concerts.

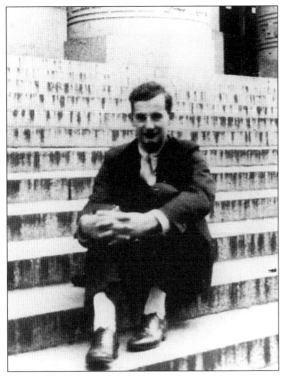

RAOUL WALLENBERG SITTING ON THE STEPS OF ANGELL HALL, EARLY 1930S. Wallenberg, a member of a distinguished Swedish family, is credited with saving almost 100,000 Jewish lives in Hungary at the end of World War II. He attended the U of M architecture school, and graduated in 1935. Since 1990, the University of Michigan Wallenberg Executive Committee has annually awarded a medal and sponsored a lecture series in his memory.

PRESIDENTIAL CANDIDATE WENDELL WILKIE ON A WHISTLE STOP TOUR, MICHIGAN CENTRAL STATION, 1940. Everyone in town, whether Republican or Democrat, came out to see Wendell Wilkie when he appeared in Ann Arbor. Presidential candidates routinely stopped in Ann Arbor, either going up to the courthouse, or, if they were in a hurry, speaking from the back of the train.

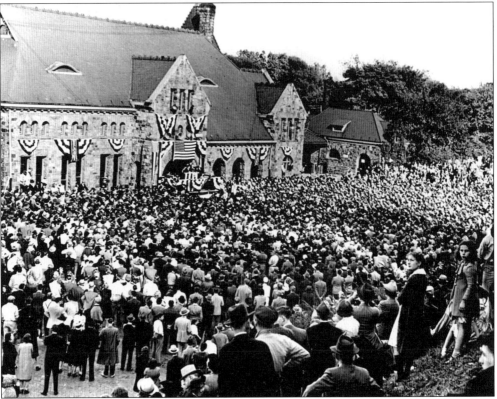

STUDENTS IN JUDGE ADVOCATE GENERAL'S SCHOOL DRILL IN THE LAW QUADRANGLE. Unlike World War I, during World War II the federal government was quick to take advantage of the unique ways the U of M could help the war effort, such as offering specialized medical and engineering training, and organizing a Japanese language school. In September 1942, JAG took over space in the Law Quad, training 2,467 Army lawyers by the end of war.

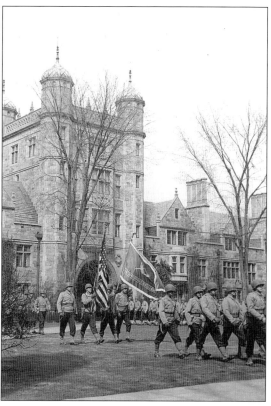

LIEUTENANT COLONIAL WALTER G. MADDOCK, M.D., LEAVING FOR WAR, JUNE 27, 1942. Maddock, a member of the U of M's medical school, organized twenty-four physicians and dentists, eleven nurses, and six technicians into a medical unit for a basc hospital overseas. Leave-taking was a regular occurrence at the railroad station during the war years.

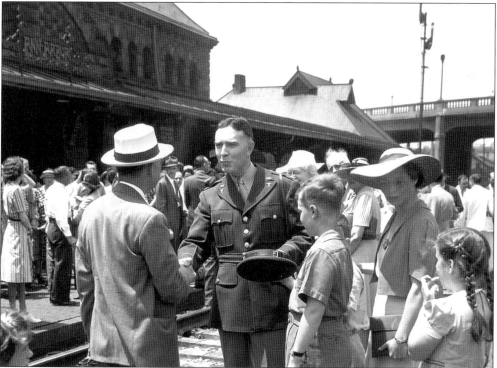

BOY SCOUTS SEEKING SCRAP
METAL AT A HOUSE ON BROOKLYN
STREET. The Boy Scouts again
aided the war effort by going door
to door picking up metal to be used
for war machinery. It was collected
all over the county, in a big
enclosed area in front of the
courthouse and near railroad
stations in smaller towns.

SOLDIERS IN FRONT OF THE OLD
GERMAN RESTAURANT. Members
of Ann Arbor's large German and
German-ancestry community
encountered prejudice during both
world wars, even though their
young men enlisted in large
numbers and their civilians took an
active role in war work. But not
everyone held their ancestry against
them. Gottlob Schumacher, who
immigrated to Ann Arbor from
Germany in the 1920s, treasured
this photo of World War II soldiers
who had just eaten a meal in his
restaurant.

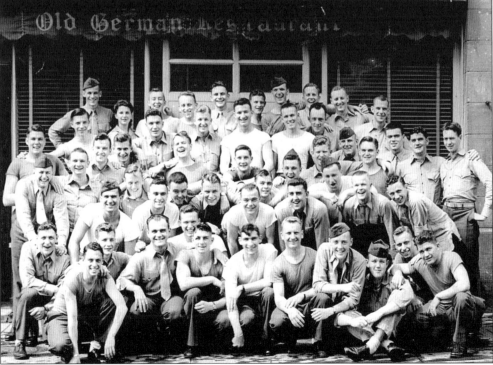

KATHERINE PFABE WORKING AT ARGUS DURING WORLD WAR II. Local industries did what they could to help during the war. The Argus Camera Company made telescopes, binoculars, tank periscopes, and artillery gunsights. American Broach operated 24 hours a day, 7 days a week, to make broaches for machine guns, as well as broaching machines and tools for making guns and artillery. Many Ann Arborites went to work at the nearby Willow Run plant, building B-24 bombers.

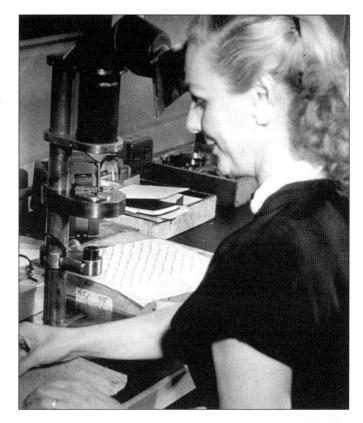

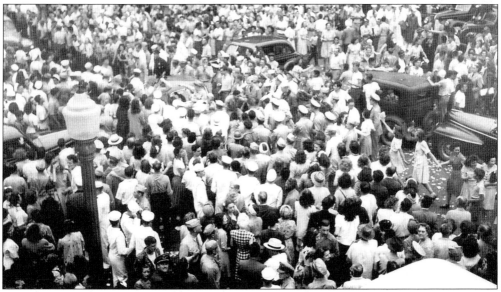

THE END OF WORLD WAR II. On August 15, 1945, people reacted to President Harry Truman's announcement of Japan's unconditional surrender by spilling into the streets. The corner of Washington and Main Streets was the focal point for the carnival-like celebration as townspeople formed snakes dances, rocked cars, and made as much noise as possible.

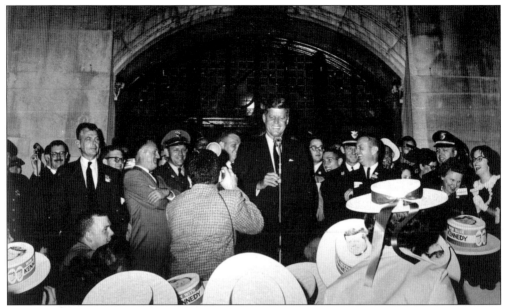

JOHN F. KENNEDY'S PEACE CORPS SPEECH, STEPS OF THE MICHIGAN UNION, 2 A.M., OCTOBER 14, 1960. During his presidential campaign, JFK chose Ann Arbor to propose the creation of the Peace Corps. "How many of you, who are going to be doctors, are willing to spend your days in Ghana? Technicians or engineers, how many of you are willing to work in the Foreign Service and spend your lives traveling around the world?" he asked the crowd. The eager listeners had stayed up until 2 a.m. to hear him speak.

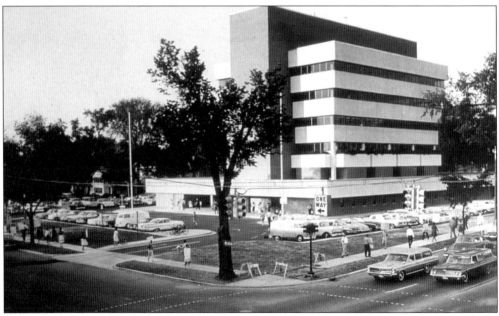

MARCHING FOR FAIR HOUSING AT CITY HALL. In 1963, after several years of campaigning by activists, Ann Arbor City Council passed the first fair housing ordinance in the state. It banned discrimination based on race, creed, color, or national origin in houses renting to five or more. Two years later, the law was strengthened to include all housing.

LYNDON B. JOHNSON SPEAKING AT THE UNIVERSITY OF MICHIGAN GRADUATION CEREMONIES, 1964. Like JFK, Johnson chose Ann Arbor to announce an idealistic program; in this case, the "Great Society," aimed at ending poverty and racial injustice.

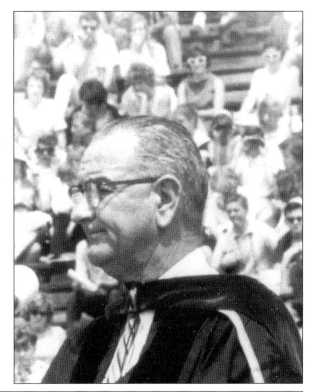

STUDENT DEMONSTRATION NEAR THE FLAGPOLE AT THE NORTH END OF THE DIAG, LATE 1960S. During the Vietnam War, students at U of M were national leaders in the protest movement. The teach-in, a method of educating people about the war, was invented on the campus in 1965. University students also organized Students for a Democratic Society. Some of its members split off into the Weatherman movement, which turned to violence to make its point about peace.

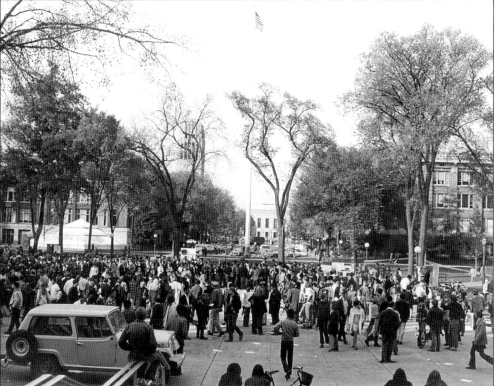

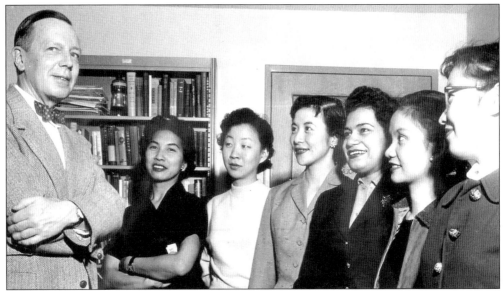

BARBOUR STUDENTS WITH UNIVERSITY OF MICHIGAN ADVISOR AND ENGLISH PROFESSOR FRANK HUNTLEY. Because of the presence of the U of M, Ann Arbor has always had a more cosmopolitan population than many other cities of its size. Asian students, many of whom learned of the university when President Angell was an ambassador to China in 1880, have always made up a large percentage of foreign students. In 1914, U of M alum and regent Levi Barbour left an endowment for financial aid for Asian women. In 1938, the International Center was organized to help the growing population of international students.

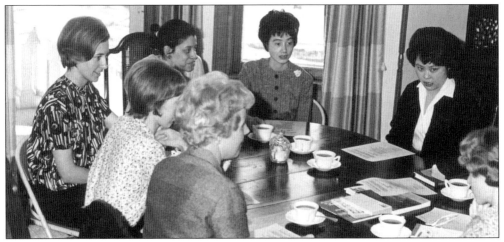

INTERNATIONAL NEIGHBORS, 1960S. In 1958, the U of M International Center requested help for the foreign wives who were beginning to arrive in Ann Arbor with their husbands. Starting with a small informal neighborhood tea, the organization grew until its offerings included English conversation, discussion, and special interest groups. By 1999, over 600 foreign women from 80 countries and 300 volunteers were participating. The growth in membership reflected the increase in foreign families moving to Ann Arbor to study, do research, or work. Another way of fostering international understanding has been the sister city program. Today Ann Arbor's sister cities include Tuebingen, Germany; Belize City, Belize; Hikone, Japan; Petersborough, Canada; Juigalpa, Nicaragua; and Dakar, Senegal.

Nine
HOMES AND SCHOOLS

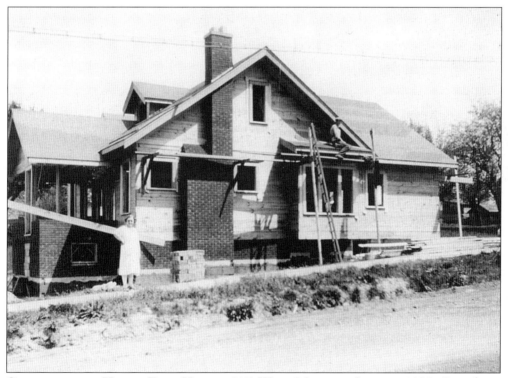

CHRISTIAN AND HULDA FREY HOUSE, 817 WEST MADISON STREET, 1927. Bungalows, single-story or one-and-a-half story houses, began showing up in Ann Arbor in the early years of the 20th century. Christian Frey, co-owner of a beverage distributorship and of Sportsman's Park (see page 124), designed this house with his wife, Hulda. Bungalows were known for their lack of pretension, use of natural materials, and low-to-the-ground design that was thought to be more in harmony with nature.

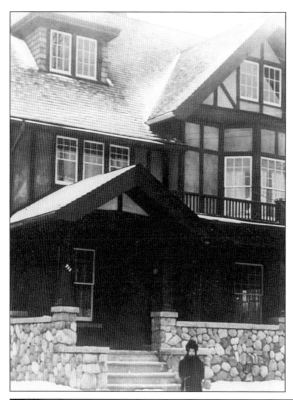

JUDGE WILLIAM AND JULIA MURRAY HOUSE, 719 WEST WASHINGTON STREET. This quintessential Tudor house was built in 1909 next door to Julia Murray's family house. (She was the daughter of organ manufacturer David Allmendinger.) During the 20th century's first 30 years, English architectural styles popped up all over town, ranging from mansions to modest family homes. The little girl in front of the house is the Murrays' daughter, Dorothy.

DEAN MYERS HOUSE, 1917 WASHTENAW AVENUE. In 1917, Myers, a professor in the U of M medical school, built this Swiss Chalet-style house when Washtenaw Avenue was replacing Division Street as the fashionable place to live. As Washtenaw Avenue got busier, it became less residential. In 1946, the house was sold to the Unitarian Church. Today it is a bed and breakfast.

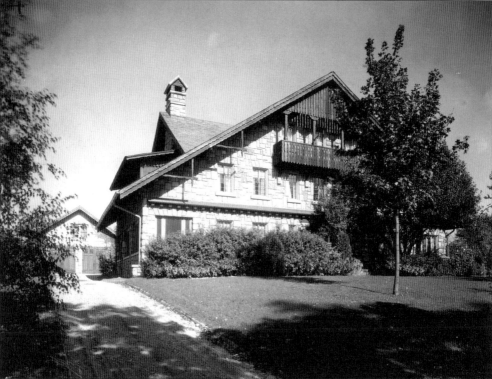

CHARLES AND VERA GOOD HOUSE, 622 SOUTH SEVENTH STREET. Built in 1925, this house was purchased as a kit from the Sears and Roebuck catalog. From 1908 until 1940, a number of firms offered a wide variety of home styles via catalog, sending the parts by rail. While most buyers hired a local contractor to put them together, Charles Good, a U of M professor of mechanical engineering, built the house himself with the help of friends.

BISHOP AND LEILA CANFIELD HOUSE, 1830 WASHTENAW AVENUE. Like Dean Myers, Bishop Canfield was also a doctor on the medical school staff who lived on Washtenaw Avenue. Canfield's house was originally an old farmhouse, but in 1930 he remodeled it in the then-popular Dutch Colonial style. In the 1950s, the Ann Arbor Women's City Club bought the house and still owns it today with an addition on the left.

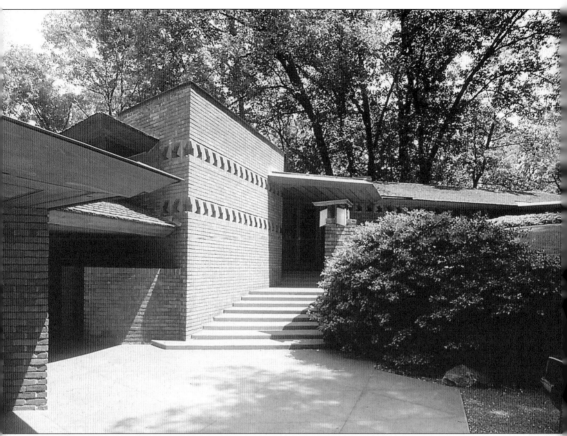

MARY AND WILLIAM PALMER HOUSE, 227 ORCHARD HILLS DRIVE. In 1952, the Palmers convinced Frank Lloyd Wright, one of the premier architects of the 20th century, to design a house for their young family. "We just asked him, it was that simple," recalls Mary Palmer. The only Wright house in Ann Arbor, it has been lovingly maintained by the Palmers.

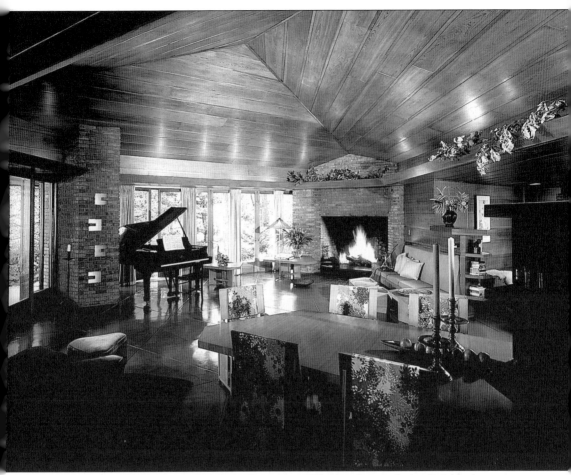

MARY AND WILLIAM PALMER HOUSE, INTERIOR. Wright designed the Palmer house in triangular modules, giving an unusual shape to the rooms. Wright also designated where the furniture should go, most of which he also designed. The house has been perfect for the Palmers' way of life, with ample room for musical concerts and entertaining.

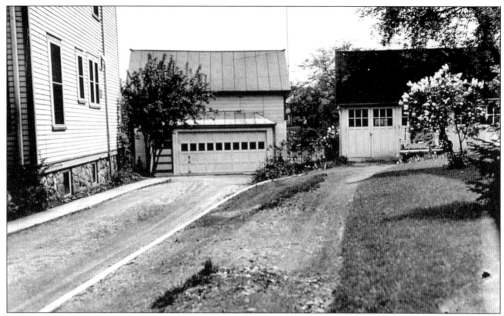

Edward and Lydia Muehlig's Garage, 801 West Liberty Street. In the 1920s, people in Ann Arbor went on a major garage-building spree, either adding to their barns, as the Muehligs did (left), or building new structures (right).

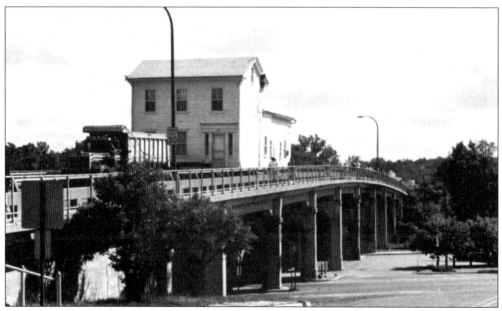

Kellogg-Warden House Carried across the Broadway Bridge, 1989. In 1989, the Washtenaw County Historical Society moved the 1835 Kellogg-Warden house, now the Museum on Main Street, to its new location at 500 North Main Street. Although some of the town's marvelous 19th-century housing stock has remained in residential use, much of it has been torn down. Preservation activists managed to save some of the best examples. The 1844 Cobblestone Farm at 2781 Packard Road and the 1853 Kempf House at 312 South Division Street are both city-owned museums.

HELEN NEWBERRY RESIDENCE HALL, 432 SOUTH STATE STREET, 1915. Ann Arbor residents began housing students in 1858, when President Henry Tappan decided that university space could be better utilized for instruction. In 1915, two women's dorms, Helen Newberry and Martha Cook, the first of their kind in Michigan, were built. Both residence halls were gifts from the children of the women they were named after. The first big dorm, Mosher-Jordan, named after Eliza Mosher and Myra Jordan, the U of M's first two deans of women, was built on the hill above Palmer Field in 1930. Although townsfolk complained when Tappan passed the housing of students over to them, they also objected when the dorms were built, worrying that their livelihoods would suffer. Male dormitory residency started in earnest after 1937 with the building of West Quad behind the Michigan Union.

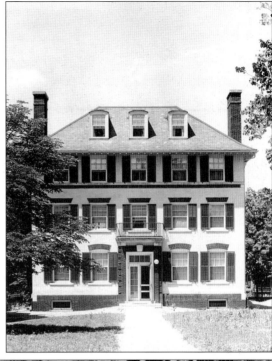

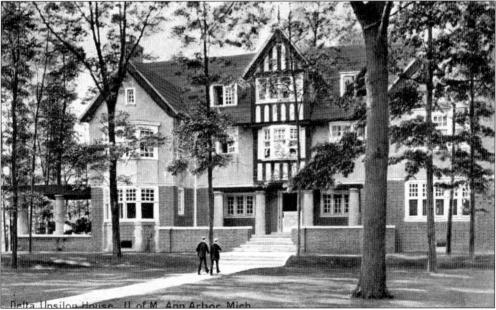

DELTA UPSILON HOUSE, 1331 HILL STREET. The 1920s were the golden age of fraternities and sororities on the U of M campus. Membership was 32 percent of male students and 22 percent of female students by 1926. At first the Greek organizations purchased private homes, but as the U of M grew, many of the big houses near campus were torn down. The Greeks eventually began building their own houses, hiring major architects of the day such as Albert Rousseau, who designed the 1912 Phi Delta Sigma house at 1443 Washtenaw (today the Trotter House), and Albert Kahn, who designed the Delta Upsilon house, above, in the first decade of the century.

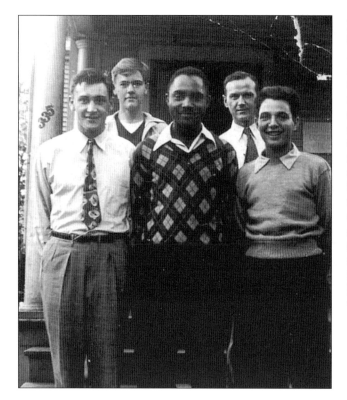

MEMBERS OF MICHIGAN SOCIALIST HOUSE, 335 EAST ANN STREET, 1933. During the Depression, members of the university's Socialist Club came up with the idea of creating a cheaper living alternative by renting houses directly and doing all the work themselves. They started by securing this house on Ann Street, which they discovered they could rent for two dollars a week, including room, board, and barber and laundry services. This student cooperative, one of the first in the nation, evolved into the Inter-Cooperative Council, which still provides housing.

COLORED WELFARE LEAGUE, 209–211 NORTH FOURTH AVENUE, 1920S. Built in 1899, this building was originally a hotel run by a series of African-American managers. In 1921, the Colored Welfare League bought it to use for community activities. The upstairs rooms were rented to black workers who moved to Ann Arbor for the jobs available in the construction boom of the 1920s. Many of these workers, in the days before fair housing laws, had trouble finding places to stay. In the 1920s, all types of apartments, from luxury to modest, began springing up around town to house the burgeoning population of students, professors, and workers.

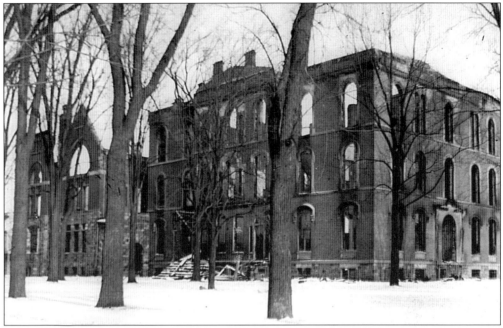

ANN ARBOR HIGH SCHOOL, 105 SOUTH STATE STREET, CORNER OF HURON STREET, 1905.
On the night of December 31, 1904, the high school burned down. School officials and students
rushed to the scene and were able to save most of the library's 8,000 books, plus some of the lab
apparatus.

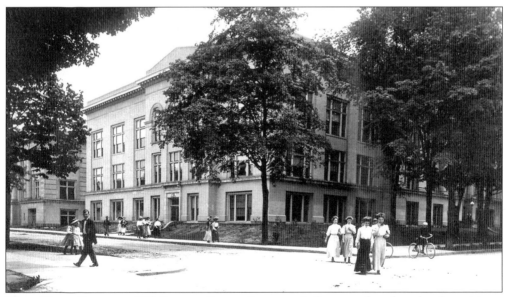

NEW HIGH SCHOOL, 105 SOUTH STATE STREET. A few months after the fire, citizens
approved a bond issue to replace the school. The building was finished in 1907. In 1953, the
school board sold the building to the U of M, who renamed it the Frieze Building after Henry
Simmons Frieze, a much-loved professor of Latin who was also acting president during several
of President Angell's absences. Pioneer High School, 601 West Stadium Boulevard, opened in
1956.

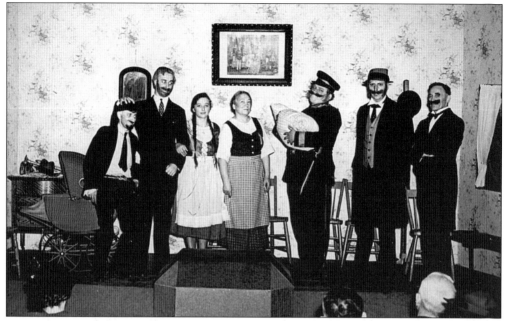

SCHWABEN VEREIN PLAY, C. 1936. The Schwaben Verein, a group with ties to Swabia, an area in southern Germany, where most of Ann Arbor's German population came from, enjoyed putting on plays in their native dialect. German immigrants from around the county crowded into the Schwaban Halle to view this rare treat.

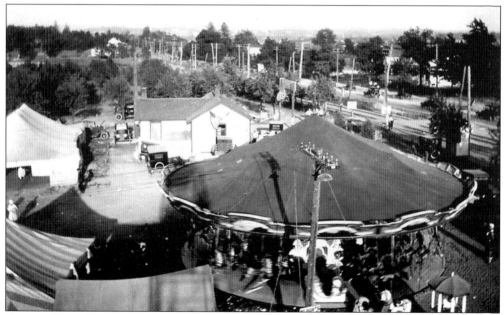

COUNTY FAIR, VETERANS MEMORIAL PARK, 1924. In 1922, the county fair moved from Burns Park to Veterans Park, where it stayed until 1942. For four days every fall, fairgoers enjoyed exhibits, music, fireworks, and horse racing. The fair offered something for everyone, including children's day, homecoming day, merchant and club days, livestock judging, and baked goods. Jackson Avenue can be seen in the background.

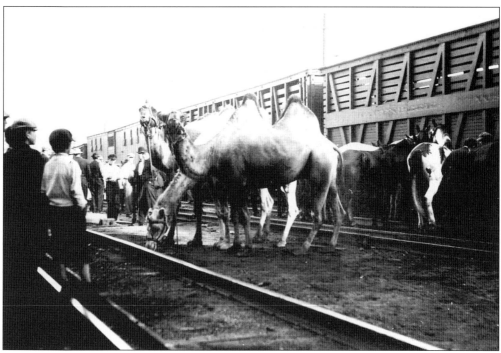

CIRCUS CAMELS ALIGHTING FROM THE TRAIN AT THE MICHIGAN CENTRAL STATION, 1913. The arrival of the circus was the highlight of many Ann Arbor children's lives. Even those who couldn't afford the show went to the train station early in the morning to watch the unloading of the circus animals.

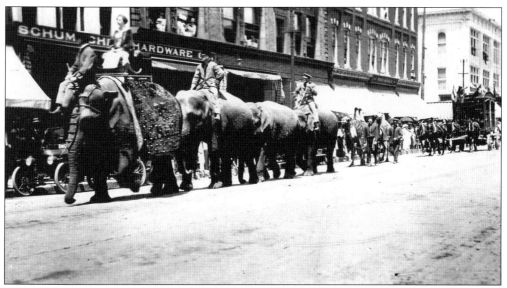

CIRCUS ELEPHANTS MARCHING ON SOUTH MAIN STREET, 1913. After members of the circus finished unloading, they paraded through downtown on the way to their camping spot. In the early years of the 20th century, they camped in Burns Park. In the 1920s and 1930s, they set up camp in an empty field at Packard Street and Stadium Boulevard. The elephants were both exotic and helpful, assisting in chores such as putting up the circus tents.

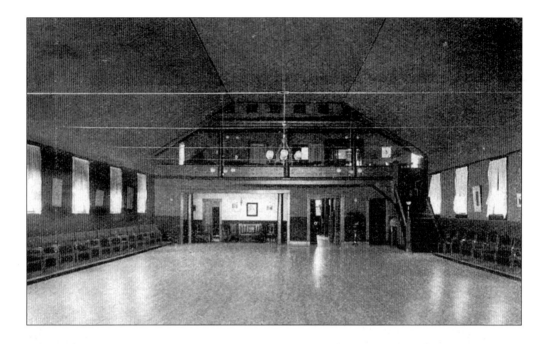

GRANGER'S ACADEMY OF DANCE, 312 MAYNARD STREET, 1900. Dancers waltzed or two-stepped to the music of Ike Fischer at the bi-weekly dances hosted by Ross Granger, who also lived at the same address. During Prohibition the popularity of dancing reached an all-time high. Barbour Gym and the Michigan Union held afternoon dances; sometimes they even scheduled breakfast dances. Many restaurants added areas for dancing, and larger private homes were often built with third-floor ballrooms.

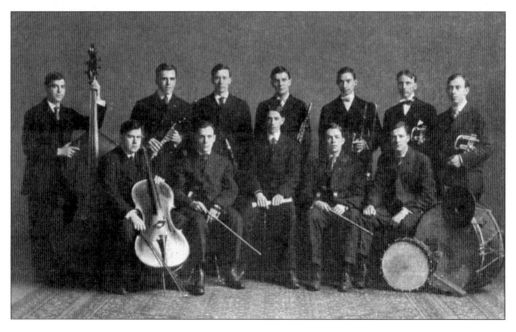

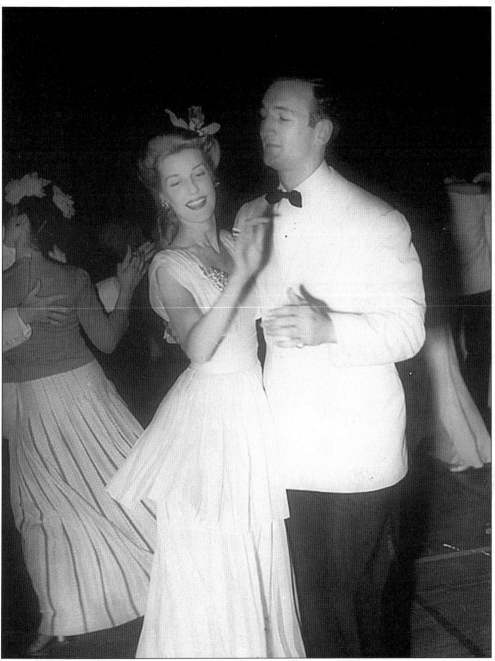

TOM HARMON AND ANITA LOUISE, 1941. U of M football star Tom Harmon created quite a stir when he arrived at the senior prom in a convertible with movie star Anita Louise at his side. His dancing time with her, however, was limited because his classmates were constantly cutting in. When local radio personality Ted Heusel was a teenager, his family lived on Dewey Street near the Intramural Building, the site of the prom. Heusel remembers watching the arrival of Harmon and Louise and later listening to the music of the Glenn Miller Orchestra as it floated out over the sleeping porch of his house. Harmon and Louise appeared together in a movie about Harmon's life.

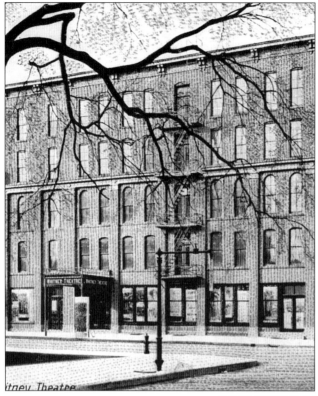

WHITNEY THEATER, 117–119 NORTH MAIN STREET. The Whitney opened in 1908, after a major remodeling of Hill's Opera House that included the addition of two floors and transformed it into one of the largest theaters in Michigan. Built for stage shows, its opening night featured the play *A Knight for a Day*, backed up with a 14-piece orchestra. Luminaries such as Ed Wynn, Katherine Cornell, Anna Pavlova, and Ted Shawn appeared at the Whitney in its heyday. In 1914, the Whitney began showing movies on Sundays. Movies gradually took over, and in 1932 the Whitney became part of the Butterfield Theater chain. The theater closed in 1952, and the site is now a parking lot.

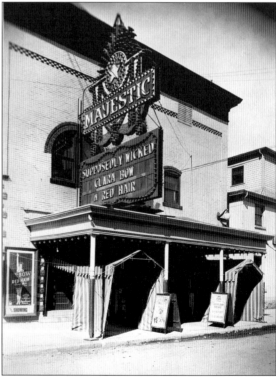

MAJESTIC THEATER, 316 MAYNARD STREET, 1928. The Majestic started life as a skating rink but was converted to a vaudeville and movie house in 1907. The theater was demolished in 1948; in 1953, the town's second parking structure went up on the site.

120

ORPHEUM THEATER, 326 SOUTH MAIN STREET, 1918. In 1913, J. Fred Wuerth built a theater next to his clothing store. The Orpheum was the first theater in town built specifically as a movie house. It became *the* place to see first-run art movies.

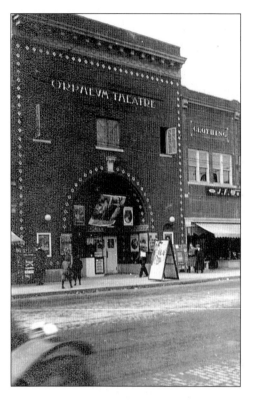

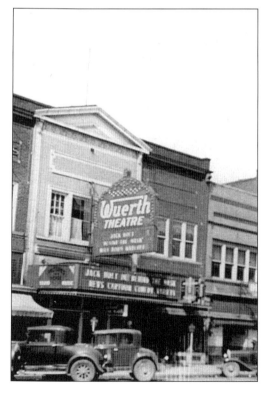

WUERTH THEATER, 320 SOUTH MAIN STREET. In 1918 Wuerth added this theater, named after himself. In March 1929, a year after the first talkie, *The Jazz Singer*, was released, Wuerth installed the town's first sound system. Although it was expensive, he rationalized that it was cheaper and less trouble than hiring orchestras and vaudeville acts. *The Ghost Talks*, the first talkie at the Wuerth, was a sell-out. Both the Wuerth and Orpheum closed in the 1950s, when people began to stay home to watch television.

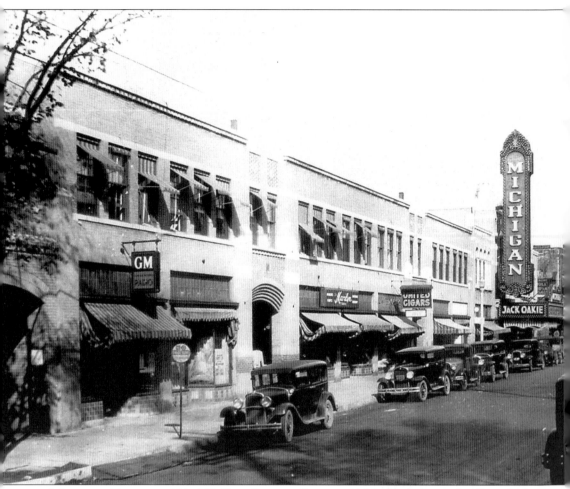

MICHIGAN THEATER, 601–609 EAST LIBERTY STREET, 1920S. Built for vaudeville and silent films, the Michigan was the largest and fanciest theater in town when it opened in January 1928. It converted to sound the next year, a week after the Wuerth. In 1979, the city purchased the theater, saving it from a dire fate such as being turned into a parking lot or a shopping mall. Today, the restored theater is still a popular movie house as well as a venue for live performances. The original Barton organ, used to provide music for silent movies, is still in use.

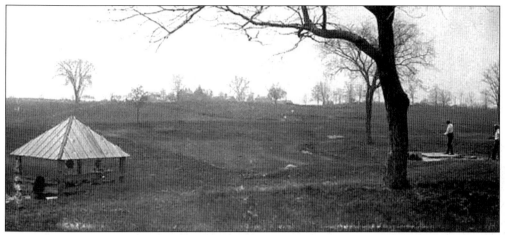

ANN ARBOR GOLF AND OUTING CLUB, 400 EAST STADIUM BOULEVARD, 1903. In 1899, the Ann Arbor Golf Club leased a farm on Ann Arbor-Saline Road, buying the property in 1903. The first golf club in Ann Arbor, it is also one of the oldest continuously operating golf clubs in the country. Orlando Stephenson, author of *Ann Arbor: The First Hundred Years*, published in 1927, wrote, "At the beginning of the century men and women of the more vigorous type scoffed at the game as one suited to men in their declining years. Today, however, it is realized that it is possible to tire out the hearty in eighteen holes and the great Scotch pastime is played by old and young of both sexes."

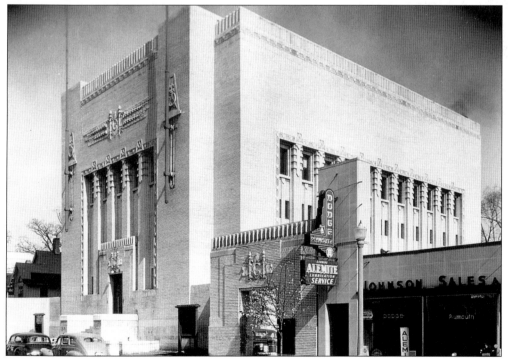

MASONIC TEMPLE, 327 SOUTH FOURTH AVENUE. The Masons, organized in 1827, are the oldest service group in Ann Arbor. In 1922, the cornerstone was laid for their new building, followed by a gala parade. Designed in an art deco style by U of M architecture professor Albert Rousseau, the building was finished in 1925 and torn down in 1975 to make room for the federal building.

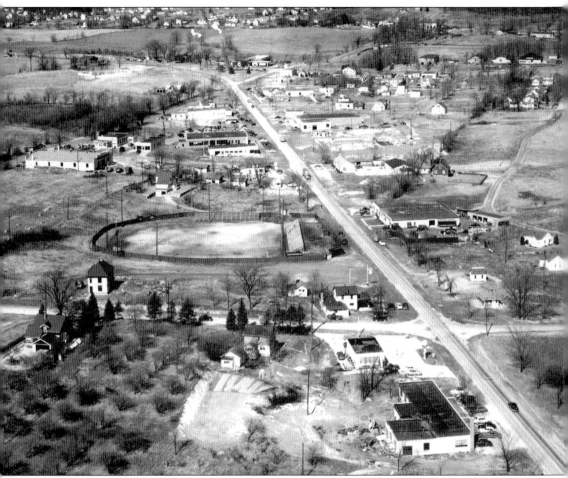

SPORTSMAN'S PARK, CORNER OF STADIUM BOULEVARD AND LIBERTY STREET, 1940S. In 1939, brothers Christian and Walter Frey built Sportsman's Park. The Freys, owners of a beer distributorship, sponsored a men's softball team called Oldbru and a women's team called Pfeiffer's. These teams and other local ones such as DhuVarren Farms, Ty's Service Market, and Grennan & Clague Groceries. challenged teams from all over the country. The rules precluded professional players, but teams made up of a sponsor's employees often practiced during work hours. The park included two electric scoreboards, a concession stand, dressing rooms and showers for the players, a press box, music, and printed programs. The teams disbanded during World War II, and the park was torn down in the 1950s.

PFEIFFER WOMEN'S TEAM, 1930s. Pfeiffer's pitcher Katie Stadel, third from left in the front row, introduced the windmill pitch to women's softball, earning her a place in the state softball hall of fame. Stadel's was the first women's team in the area, formed in the early 1930s when a group of young women who lived near each other played at Wines Field. Others followed and soon a women's league was established. They played women's teams from as far away as Lansing, Saginaw, and even Windsor, Ontario. Stadel learned the windmill pitch after observing a Lansing men's team using it. She practiced all winter and introduced it in the spring of 1938. Stadel's husband, Elmer, far right, helped with the team.

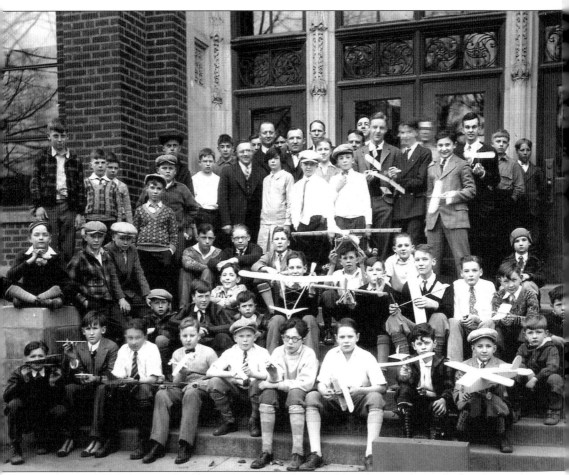

MODEL AIRPLANE CLUB IN FRONT OF UNIVERSITY HIGH SCHOOL, 1936 Boys followed their fathers' example in organizing clubs around shared interests, in this case airplanes, an exciting idea in the early years of aviation.

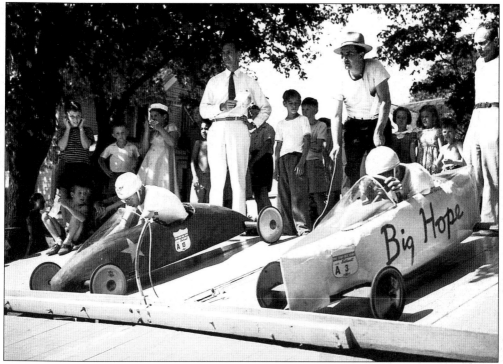

SOAPBOX DERBY, BROADWAY HILL, 1941. Boys bonded with their fathers by working together to fashion soapbox cars out of a limited number of materials. The boys raced down Broadway Hill in Lower Town.

ELSA ORDWAY AND FRIEND PLAY COWBOYS AND INDIANS, C. 1912. Time goes by, but children still enjoy playing games, as they did many years ago.

Photo Credits

All references are to collections in the U of M Bentley Historical Library unless otherwise noted.

Pages two and four: Sam Sturgis.

Chapter One: Sturgis, Mel Ivory. Other: Doug Smith, Walter Metzger, Ruth Dalitz, Doug Price, Gottlob Schumacher.

Chapter Two: Sturgis, Oscar Buss, Michigan Historical Topical Photograph Collection, Ivory, Post Card, Alumni Association. Other: Irene Hieber, Bob Kuhn.

Chapter Three: Staebler, Ivory, Sturgis, Alumni. Other: Mike Logghe, Bob Kuhn, Henry Michelfelder, Nancy Crosby.

Chapter Four: Sturgis, Ivory, Buss, Post Card, Joyce Jones, Emil Lorch. Other: Olive Conant.

Chapter Five: Sturgis, George Swain, U of M Vertical File, Alumni Association, News and Information, Ivory, U of M Department of Physical Education for Women. Other: Richard Wood, Ila Ridenour.

Chapter Six: Sturgis, Post Cards, Buss, Vertical File. Other: Linda Strodtman.

Chapter Seven: Sturgis, Gardner Williams, Swain, Vertical file, Post Card. Other: Dorothy Wagner.

Chapter Eight: Sturgis, Paul C. Wonderly, Ivory, News and Information, Ivory, Law School, Barbour Scholars, Art Gallagher. Other: Ann Staiger, Penny Schreiber, Herb Pfabe Jr., Gottlob Schumacher.

Chapter Nine: Sturgis, Swain, Post Cards, Ivory. Other: Helen Frey, Dorothy Wagner, Diane Good, Balthazar Korab (the Palmer pictures), Fay Muehlig, Susan Caya for the Inter-Cooperative Council, Pauline Walter for the Washtenaw County Historical Society.

Chapter Ten: Michigan Union Records, Sturgis, Buss, Vertical File, Alumni, Ivory, Wilfred Byron Shaw Papers. Other: Walter Metzger, Susan Wineberg.